Le regard fait le tableau

Marcel Duchamp

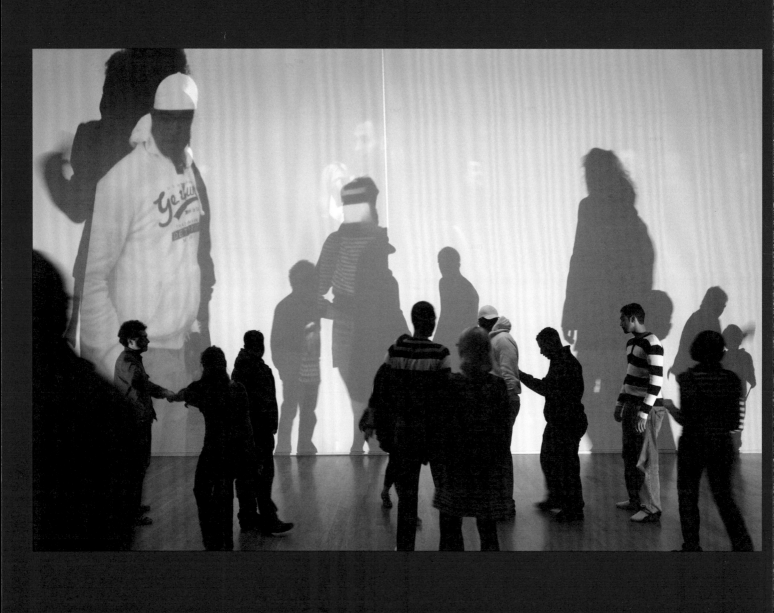

Rafael Lozano-Hemmer

Recorders

Contents

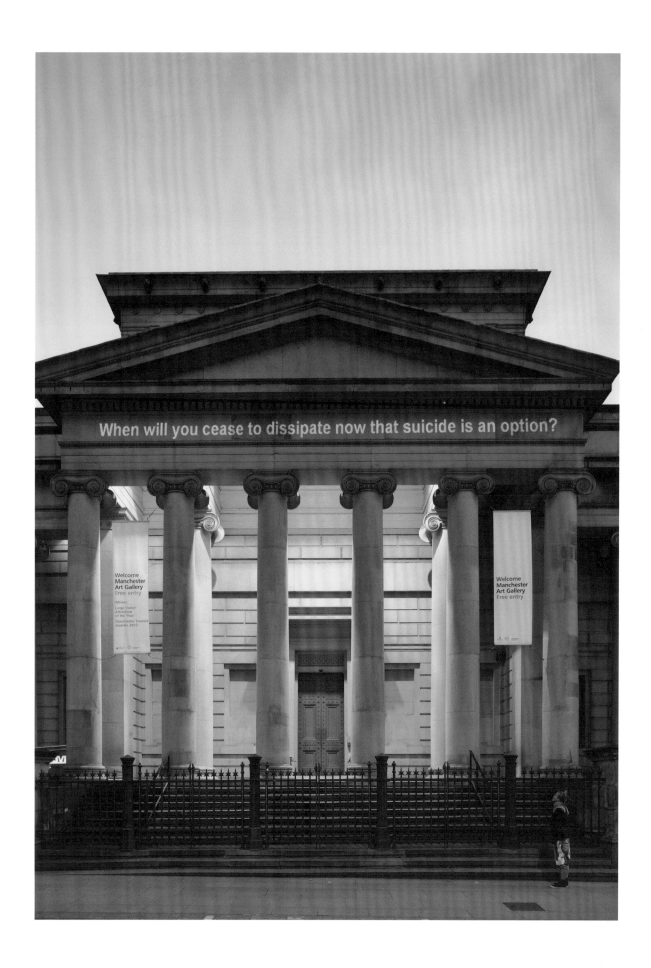

Moira Stevenson

Foreword

Recorders is major new exhibition of interactive artworks by Mexican-Canadian artist Rafael Lozano-Hemmer, including the world premieres of three new works, *Autopoiesis*, *Please Empty Your Pockets* and the large-scale installation *People on People*. *Recorders* also features five other specially adapted pieces most of which have never been on public display in the UK before, including the highlight of the artist's contribution to the Mexican Pavilion at the Venice Biennale in 2007, the seminal *Pulse Room*. The exhibition is a lead event in the Northwest's Abandon Normal Devices (AND) Festival of New Cinema and Digital Culture, and marks a particularly exciting moment for the region's contemporary art scene.

The UK is one of, if not the most, heavily surveillanced countries in the World. We have an ambiguous relationship with this situation of control. Neighbourhood Watch schemes and local retailers call for ever increasing numbers of street-mounted cameras or supersonic sound devices which only the under-18s can hear in order to deter a perceived threat from our young people. We walk through shopping arcades oblivious to our images and paths of casual browsing being stored and kept by private security firms. We have spent our evenings watching *Big Brother's* voluntary incarceration-as-entertainment scenario, we follow the night-vision and thermal-imaging chases of *Police, Camera, Action!* or more recently, and disturbingly, we have been invited to watch with amusement or horror YouTube clips of such random acts of violence as a woman throwing a cat into a wheelie bin recorded by private individuals on CCTV or webcam devices. Our storecards leave a trace of exactly what our eating habits are and Amazon knows our taste in reading and listening. Visitors to

this gallery too are watched as part of our standard security for the building. And yet we respond with indignation at the government's scheme to introduce identity cards fondly imagining our privacy and identity are sacrosanct and inviolate. Meanwhile our identities, our movements (our thoughts perhaps?) are already in the domain of others.

Lozano-Hemmer's work is highly appropriate in the context of this social landscape and our attitude to controlled and watched public space. In *Recorders* the public are an integral part of the artwork. All of the works have memory and people leave traces of themselves, whether it is objects from their pockets, questions they have typed, the pace of their heartbeat, their voice or their image. In all cases the artwork compiles a database of behaviours that then becomes the artwork itself. Without public participation the artworks would not exist. Lozano-Hemmer encourages interaction on a personal and communal level that promotes a new form of exchange and collaborative production with the public.

There is a playful element to the interaction with each of the works, but as participants engage with them, their more ominous or predatory nature emerges. New commission, *People on People*, sees the gallery transformed into one of the world's most advanced people scanners. As we enter the gallery powerful projectors create what appears to be a giant shadow puppet theatre and portraits are revealed inside our own shadows. However, we don't see ourselves, images of other people are shown within our shadow (gathered by a sophisticated surveillance system), and these images become animated and look out at us when they are revealed by the shadows, creating an uncanny and unsettling effect.

Recorders is a world class example of how digital technologies can be used to create groundbreaking, innovative contemporary art which inspires, involves and stimulates audiences. It is taking place at a significant time for Manchester, the city where the computer was born. Manchester is actively working to bring the creative and digital sectors closer together to achieve an ambition to create a hotbed where creative talent is nurtured, and where cutting-edge artforms and new models of creative practice can emerge and be exploited locally, nationally and internationally. By investing in the city's digital infrastructure, creating the conditions where artists and creative practitioners can connect, play and experiment with digital technologies in their work the city is laying the groundwork for the future. To this end alongside *Recorders* Lewis Sykes and Cybersonica working with Openlab Workshops have created *Make It Yourself*, an exhibition showcasing submissions of people's creativity using open source software and Arduino hardware to create inventive DIY examples of electronic-circuitry projects.

The exhibition has been generously supported by a number of funders. *Recorders* is the third exhibition in a series of world-class exhibitions at Manchester Art Gallery on the theme of Radical Manchester which have been made possible through the strategic support of the North West Regional Development Agency. We are delighted to work for the first time with the Abandon Normal Devices (AND) Festival of New Cinema and Digital Culture, who have co-commissioned *People on People* and are an important partner in the realisation of the city's creative and digital technology ambitions. We are also very grateful for support received from Arts Council England and The Henry Moore Foundation, who have supported the new commissions, events programme and publication, and finally to the Embassy of Mexico to the United Kingdom who have also made a generous contribution to help make this project happen.

Finally and most importantly, I'd like to thank Rafael Lozano-Hemmer and his production team who have all worked ceaselessly throughout the summer to deliver this ground-breaking exhibition.

Moira Stevenson
Head of Manchester City Galleries

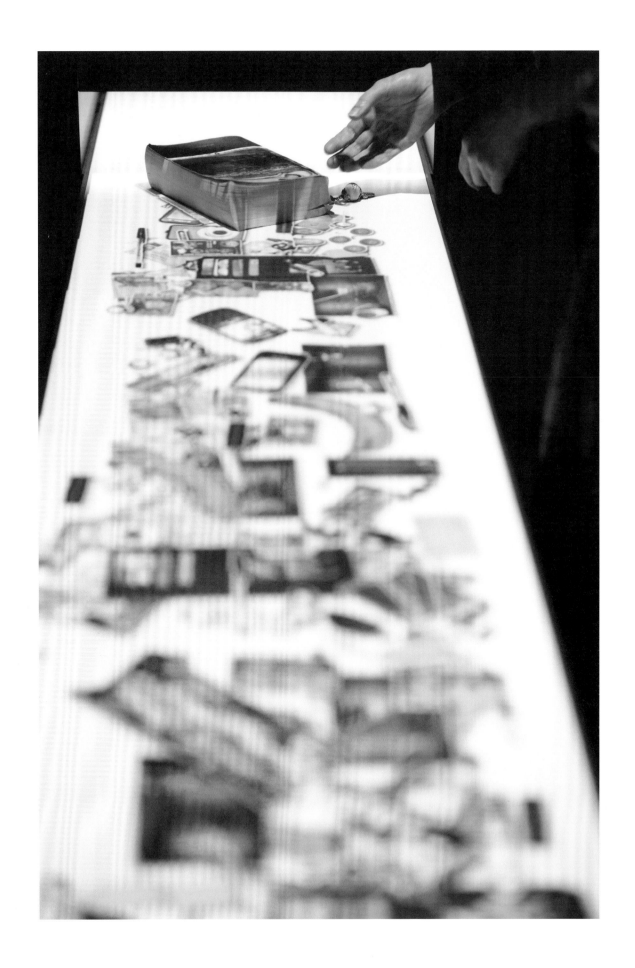

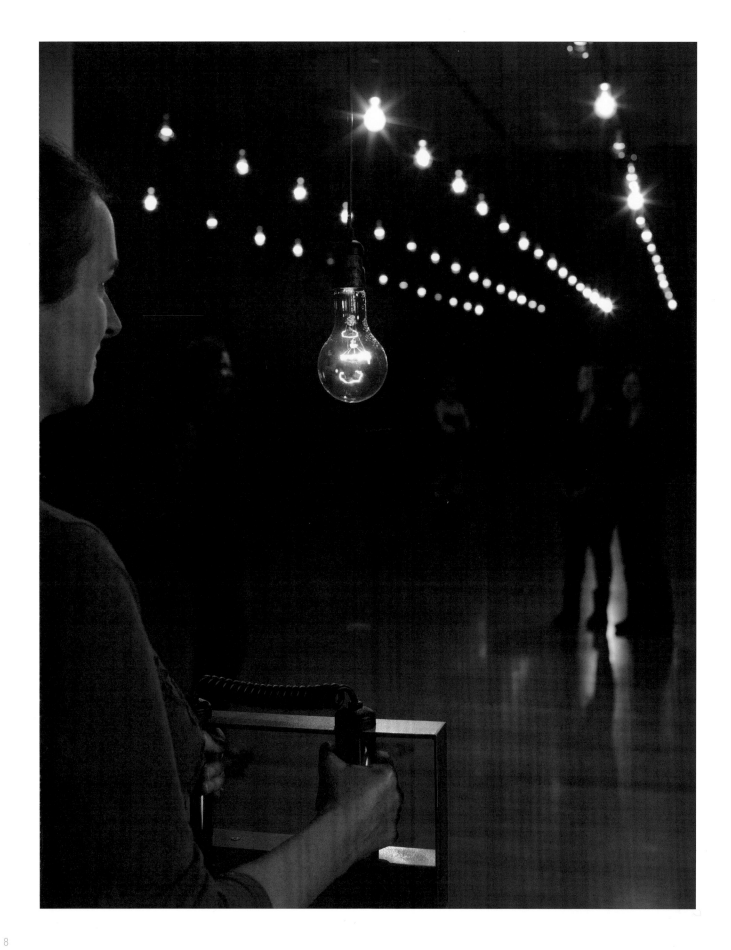

Rafael Lozano-Hemmer

Artist's Foreword

In 2007 Sabine Himmelsbach invited me to do a small exhibition at the Edith Ruß Site for Media Art in Oldenburg and I proposed a show called Recorders that contained three artworks. I am delighted that Manchester Art Gallery has given me an opportunity to explore this theme further and make an ambitious solo exhibition. I have developed five additional pieces which I believe are quite diverse and yet offer a coherent experience of crowd-sourced art.

I would like to extend my gratitude to the wonderful people that made this exhibition possible, in particular Tim Wilcox and Fiona Corridan who are great to work with. The entire Manchester Art Gallery team listed in the final pages of this catalogue have addressed the complexities of this exhibition with efficiency and elegance. Emily Bates from bitforms gallery in New York initiated and followed through the show, and Nina Miall from Haunch of Venison gallery in London was also instrumental. Apart from bitforms and Haunch, my other galleries have been very supportive: OMR in Mexico, Guy Bärtschi in Geneva and Max Estrella in Madrid.

I am honoured to have what I consider three key author-curators write about my work, their essays weave a dense web which help the works have multiple points of entry. Mil gracias Timothy Druckrey, Ceclilia Fajardo-Hill and Beryl Graham.

Finally, I have nothing but praise for my studio team, who produced the artworks on display and who tolerated me when I doubled up my dose of Synthroid, in particular thanks to Conroy Badger, Gideon May, Stephan Schulz (who was also an excellent exhibition coordinator), Karine Charbonneau, David Lemieux, Susie Ramsay, Guillaume Tremblay and Pierre Fournier.

In 1996 I had the pleasure of interviewing Argentinean writer Adolfo Bioy Casares in Madrid, he was 82 years old then. My friend Perry Hoberman had recommended his seminal novel *The Invention of Morel*, written in 1940. In the novel the protagonist falls in love with a woman who turns out to be a three-dimensional projection, a recorded loop. I spent a long time telling the maestro how his work was so influential to electronic artists, how for example Manchester-based artist Paul Sermon was making possible some of his visions. I spoke far too long about how his work shows that absence and presence are not opposites, that at any given instance many realities are co-present. 'Yes, yes' he said. Then he turned to my assistant and asked her politely 'excuse me miss, but while he talked I couldn't help ask myself: are you wearing a garter belt'?

This exhibition is dedicated to the memory and playback of Adolfo Bioy Casares.

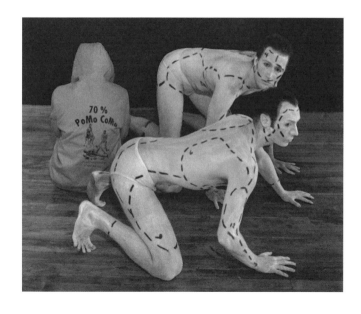

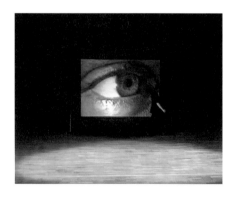
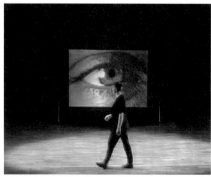
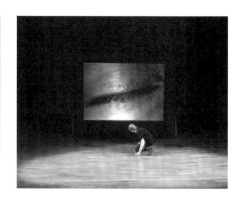

Jacinta Laurent

Interview: Rafael Lozano-Hemmer

Can you tell me about how you started doing art?
I started my career in the late 80s working with a group called PoMo CoMo that performed *Technological Theatres* and radio art. Our shows featured an excessive amount of computerized audiovisual gear and the subject of the shows was technology itself, – in particular, the joy of computers crashing. Our strategy was simple: 1) Overpromise, 2) Underdeliver, and 3) Apologize. Today I look back at that early body of work and I call those pieces *Crashers*. They are engines of empathy and irony. I still make crashers: at the studio we are developing an autonomous rover that instead of a solid body has a large convex lens, which concentrates the sun's rays and burns the wooden platform underneath it, over which it drives, until it gets stuck in the ashes.

I have read that you consider your work closer to the performing arts than the visual arts, what attracted you to theatre and performance?
I met Jesusa Rodríguez, an incredible Mexican performance artist, while still with PoMo CoMo. She took issue with the name *Technological Theatre*. She asked: 'how can you mix something as advanced and sophisticated as theatre with something as primitive and infantile as technology?'. She was right of course, the language of electronic aesthetics and criticism did already have many speakers but it took a while for the dissemination of critical theories that brought some maturity and historical perspective to the field. Still, clearly rich theatrical approaches are valuable to stage artworks which take place – or create place – over time. So for a few years I worked with another group called *Transition State Theory* in a series of performances where dancers and actors would directly control their lights, video and sound. After each performance the general public was invited to try out the sensors used by the cast so they could see that in fact the show was not just rehearsed to synchronize all the media, but that real-time interaction drove the entire stage. I call those pieces *Performers*, as they are in a way 'instruments' that are best played by trained actors, dancers or musicians, followed by interaction from the public. I still make performers: recently the Guggenheim Museum commissioned *Levels of Nothingness* a show where the voice of an actress, reading a libretto on the philosophy of colour, automatically triggered and controlled a full rig of Rock and Roll moving lights.

Do you fit all your work into series like *Crashers* and *Performers*? Are there other series?
Well, they are not really series, more like keywords or categories that describe certain common traits, 'metadata' to use a nerdy buzzword. Coming out of the studio are other kinds of artworks: *Generators*, *Subsculptures*, *Trackers*, *Antimonuments*, *Glories*, *Recorders*, *Manifestos* and many others.

So can an artwork belong to several categories?
Exactly! For example, like many of my colleagues in media art, some of my pieces use recursive algorithms, cellular automata, fractals or fluid dynamics to create complex behaviours that cannot be controlled, preprogrammed or predicted. The introduction of these 'non-linear maths' gives pieces the capability to have 'emergent' properties that are not random nor pre-established. I call those pieces *Generators*. An example generator is a recent piece called *Solar Equation* which was a scale model of the Sun, one hundred million times smaller than the real thing, showing computer-generated flares, turbulence and sun-spots.

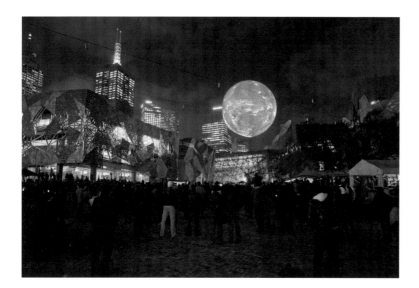

The project was also an *Antimonument* because it was an ephemeral intervention in public space that was always changing and did not seek to commemorate a famous or notable person or event.

Let's talk specifically about *Recorders*, what is that typology?

Recorders are artworks that hear, see or feel the public and record and replay memories entirely obtained during the show. The pieces either depend on participation to exist or predatorily gather information on the public through surveillance and biometric technologies. The pieces are meant to oscillate between the seduction of participation, preservation and inclusion, and the violence of Orwellian and ubiquitous computerized detection. In all cases the artwork compiles a database of behaviours that then becomes the artwork itself. In most cases one must participate in order to see or hear an output.

Will people feel uncomfortable, like they are being 'put on the spot'?

Depends on the piece. Formulating a pre-eminent role for the spectator in an exhibition is a call to engagement, intimacy, personalization and agency, while simultaneously it is a policing, a loss of authorial and curatorial control, and the introduction of narcissistic cultures of endless self-representation. As critical distance, objectivity and voyeurism is not possible in this 'crowdsourced' show, it will hopefully displease those who believe art should be timeless and universal.

Why do you want to displease?

I want to displease those who have condescending and paternalistic attitudes towards the general public. Some museums, artists, curators and critics secretly (and sometimes openly) assert that most visitors are morons, that their contribution should be limited to the gift shop. In my experience, giving responsibilities to the public is always rewarding, it is great to be surprised by what they come up with. I am ready for *Recorders* to be panned by art critics who will see the show as a set of pavlovian tests, as a science museum, or as a populist exercise, lacking sophistication. When you see the video portraits in the new installation *People on People* sure enough you will not get the masterful aesthetisation that Bill Viola, Gary Hill or Pipilotti Rist achieve, but what you gain is a sense of improvisation, of event, of projected absence, of art as process, with the process including the contemplation of – and therefore the participation in – the work itself. Even though the art of participation has been around for centuries, many critics can't get over the idea that a small elite should be able to dictate what is a worthwhile exploration.

So in the realm of interactive art there is little room for the role of the artist, the curator, the critic?

There is a lot of room! The artist derives a personal language from his or her nightmares, experiences, failures, influences, and then uses this to construct a platform, to improvise some constraints, to connect disparate realities, to materialize rich ambiguities. The curator becomes the host, creating a context for the work but also for the people, no longer so concerned with the preservation of the art object but with the perpetration of the cultural act. The critic becomes an empiricist, participating in the works and potentially embedding his or her own views so they become part of the artwork; also the critic can observe

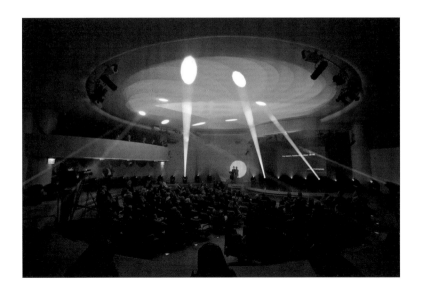

Levels of Nothingness 2009.
Performance commissioned for the 50th
Anniversary of the Guggenheim Museum.
The human voice is analyzed by computers,
automatically controlling a rig of Rock-
and-Roll concert lighting and creating an
interactive colour environment. Performed
by Isabella Rossellini, libretto co-written
with Brian Massumi. Photo: Kristopher
McKay.

and relate the participation of others, a kind of comparative social anthropology upon which to base his or her apology, deconstruction, praise or dismissal.

Is there the possibility of resistance? Can one hide from your work?

I know that I am complicit with what I am denouncing: computer vision has built-in prejudices, exhibition spaces are never neutral, materializing surveillance just normalizes it, and so on. I work with technology not because it is new but because it is inevitable, a 'second-skin' as McLuhan would call it. So is it possible to resist technology? Well Pol Pot tried. No, technology is like a language that we cannot pretend is optional. Even if you live in a tiny village in remote Oaxaca and have never made a phone call, let alone seen a computer, your life is affected by global warming, your country is run on virtual capital, your language is about to disappear as more and more people seek to be connected with a handful of mainstream global languages. What we can do is pervert technology, to misuse it to create connective, critical or poetic experiences, to make evident its presence and the way it limits, expands or constructs our identities. As for hiding from my work, certainly it can be done by not participating, although all artworks in *Recorders* are pretty vampiric; *People on People* in particular will find and track you and record you no matter what...Your best bet is to wear a disguise!

Is there a message that you seek to convey with these works?

Not really any one message – in fact the whole notion of communication in art is very problematic and corporate. In my opinion good art slows down communication, adds noise, intercepts and miss-translates messages, creates intricate silences...nothing that a telecom could derive a profit from. In *Recorders*, all the pieces are different and they are all experimental, in the sense that they are out of my control, uncensored and unmoderated. I am very curious to see what people will do. In *Recorders* Frank Stella's minimalist quip 'what you see is what you get' becomes 'what you give is what you get.'

Jacinta Laurent is a researcher currently living in Montreal. Her book on conceptual art *Test in the Head* is forthcoming.

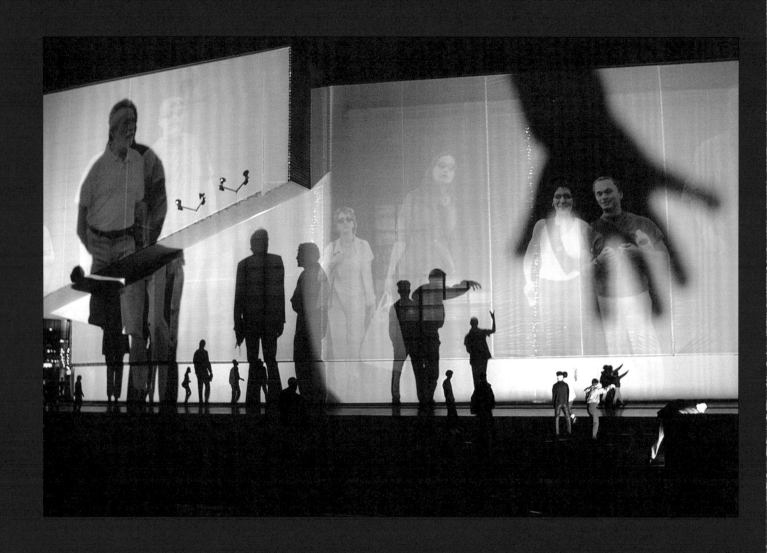

Body Movies 2001.
Shadows of passers-by reveal
thousands of portraits of people
from the city. Commissioned by
V2 for Cultural Capital of Europe,
Rotterdam. Photo: Arie Kievit.

Beryl Graham

Delicate Controls

A delicate differentiation of interaction

11.00 am Until now about 80 visitors in the office. Half, however, remain standing in the doorway and look around, others walk past the blackboards, and then remain longer in the office. Some only come to the door and leave in fright, as if they had come into the wrong restroom.

Joseph Beuys and Dirk Schwarze 1972[1]

As even the mighty Joseph Beuys discovered, hosting interaction or participation is not easy. At the *Documenta 5* art festival he installed the *Bureau for Direct Democracy* for 100 days, and remarked upon the behaviours of the audience: when called upon to suddenly participate in art contexts, audiences might justifiably behave as if they had '... come into the wrong restroom'. Perhaps it was the famous Beuys hat that put people off from entering the space, perhaps it was some of the other highly complex variables which affect human behaviour, not least of which is the fact that one is not often called upon to participate in art. The wide range of skills needed by an artist to make participative art are hugely impressive to me, and as a curator of contemporary art (both new media and not) over a number of years, certain needs have become clear: firstly the need to define what kind of reaction, interaction, participation or collaboration is intended, and secondly the need to understand what contexts of display might relate to which kinds of 'behaviours'.[2]

New media artists in general show impressive understanding of systems and networks – those complex hierarchies of who is connecting with what – be that audiences, co-producers, artists, software or objects. Rafael Lozano-Hemmer's body of work in particular has greatly informed definitions of different kinds of interaction, by delicately differentiating subtle variations. His *Body Movies* series, for example (the basis for *People On People*), shows several kinds of reaction and interaction in the same work. The first can perhaps be seen as a gentle introduction to the space and the artwork: if audience members cover the projections of photographs of people with their own shadows, they can see the image properly, and perhaps reflect on themselves in

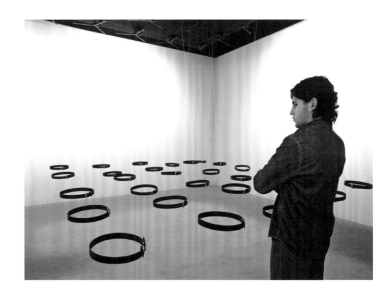

relation to another person. Secondly if several people cover the photographic images at the same time, the computer program reacts by showing a new set of photographs. This is the programmed artwork reacting to the audience and is a fairly basic affordance of new media, but one which obviously profoundly affects the reading of the work. The extra level here is that the audience members need to co-operate with each other in order to make this happen, and this will depend on the context and the social skills involved. This is interaction between people, intended by the artist in order to gain a reaction from the artwork. The third kind of interaction is further outside of the control of the artist, but intended nevertheless. The audience may ignore the photographs, and use the big shadows either for personal spectacle or for interaction between people. Cue much gleeful sexual horseplay and different levels of mock violence, made curiously 'safe' by being shadows, but also involving creative interplay using props and imagination. Lozano-Hemmer has done much observation of the behaviours involved, including the ways in which any individual or group monopolising the platform or behaving in ways too violent or sexual, can be controlled by others cooperating to stand in front of the lights.[3] As the artist has noted, without the thoughtful 'hosting structures' to introduce people to interaction, only children (or perhaps the chemically disinhibited) will participate.[4] The artist is here acting as a gracious 'host' for interaction between people, from a starting point of the computer programme's reaction to human input. Without the reflective 'shadowing' of photographs of other people, would the quality of creative shadowplay diminish?

The artist's understanding of behaviours informs these decisions, and the 'distance' afforded by using shadows, and photographic images of other people, makes the interactions less socially risky. In the artworks *People on People*, and *Microphones*, the distance of time also helps to smooth the social anxieties of interaction in a gallery space: other people are present, but this might be as a distant echo... In *Pulse Room* the human presence is particularly elegant: each small personal spectacle of electric energy slides gently into the community pool, and when each flicker shuffles off the end of the grid, there is a sense of loss and evanescence. The tension between individual egoistic spectacle, and co-operation, is a fascination in Lozano-Hemmer's work: Do we treat each others' shadows with respect? Are we tracing only our own heartbeat? Unfortunately, that tension between the individual and group is one that is already firmly decided by much mainstream art criticism, and is a position which makes the development of a serious aesthetics of participation very difficult: to cite Hal Foster concerning Rirkrit Tiravanija's work, for example, 'This is where I side with Sartre on a bad day: often in galleries and museums, hell is other people.'[5]

Somewhere between heaven and hell lies a delicate balance between the individual and the group, and for the artist, a balance between artistic control and being a self-effacing host. As Lozano-Hemmer has said, 'successful pieces that feature 'interactivity for groups' are usually out-of-control'.[6]

Control and technology

Race and other forms of cultural difference have been historically presented as secret unknowns that require definition, mapping, measuring and legislating by those in power, in order to render them public.
Jennifer González 2010[7]

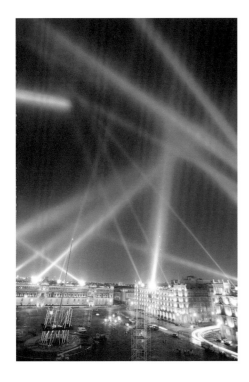

Vectorial Elevation 1999.
Light designs made by visitors to
web site www.alzado.net. First
installed at the Zócalo Square in
Mexico City. Photo: Martin Vargas.

Art using contemporary technologies often struggles with a critical response which is based on a kind of 'virgin/whore' dichotomy of cultural meaning: these technologies are fluffy 'hands-on fun for kids' – entertaining enough but essentially shallow – a gossipy world of mass media chat rooms, networked bitching and vapour theory; alternatively, these technologies are military-industrial nightmares of command and control – networks of iris-scan surveillance, genetic mapping databases, smart bombs, and shock-and-awe commercial advertising. As Jennifer Gonzalez points out, this also places technologies on the disputed borders of public and private, and at the centre of issues of 'embodiment'. If a non-citizen has been through USA entry procedures, then their fingerprints are now recorded.

Lozano-Hemmer's body of work has been acutely aware of these embodied meanings of technology, from private to public, or from intimate and moving experiences to spectacles of command and control. His early work involving huge publicly-controlled searchlights in public spaces made specific reference to Nazi light-shows and spectacles. *Standards and Double Standards* is his gallery installation where a set of men's belts turn to face the viewer in the room; a sinister installation on a claustrophobic scale, inferring domestic surveillance and violence. In the *Recorders* exhibition, the emphasis is on exactly who is 'recording' what: *Pulse Index* places our skin identity alongside that of other people, but unlike the immigration databases, allows the samples to fade into the forgiving oblivion of forgetting. *33 Questions per Minute* references the sublime evanescent deluge of chat online, whilst also posing 'who asks the questions here?' As a Mexican-Canadian who has also lived in Europe, Lozano-

Hemmer has crossed particularly disputed borders, and would be aware that some people are more recorded than others. Again, there is a particular tension here between the individual and the group: Gonzalez also explains that 'Race has traditionally been thought of as a 'quality' of individuals, therefore reducible ... to a property or mere set of appearances that one can theoretically 'move beyond'. But race is not a property; it is a relation of public encounter.'

In acknowledging the intensely negative aspects of both technology and interaction in his work, and by exploring those tensions between individuals and the group, and in particular the complex 'relations of public encounter', Lozano-Hemmer has admirably addressed the current issue of taking interactive work beyond saccharine 'hands-on fun', and into spaces where conflict can be faced.

Relational Architectures

It seems to me that there is an urgent need to undo the innocence of participation. Isn't this kind of practice precisely the modus operandi that we can find in so many 'socially relevant' practices today? It seems interesting how particular practices have hijacked the notion of participation as an unquestionably positive, user-driven means of engagement. In this context, it could be useful to think through a concept of 'conflictual participation' as a productive form of interventional practice.
Markus Miessen 2007 [8]

Recently, there has been some debate in the contemporary art world about participatory art, with Nicolas Bourriaud's 'Relational Aesthetics' criticised by Claire Bishop for a lack of space for conflict in participatory systems.[9]

This has caused some wry amusement to those who have worked in socially engaged art for many years, and those in new media art, who are well over the hump of the hype-cycle concerning interaction, and have established a critical vocabulary for exactly what might relate to who, and in what way. Lozano-Hemmer was using the term 'Relational Architecture' some time before this recent debate and it still forms a useful term for accurately reflecting the nature of 'planning' interaction – artists, like architects, might cunningly design a 'shell' within which certain behaviours might be encouraged, but despite all the modish 'user-driven' participation in the world, the architect is still not in control of the audience or user who might inhabit that 'shell'.

What remains is a continuing incompatibility between mainstream contemporary art, and participatory art systems, in several ways: the existing fine art star-system of big names makes more self-effacing roles for the artist in terms of 'authorship' problematic; art criticism has a problem with the 'quality' of participation; and issues of 'control' in relation to audience are often an anxiety for curators. There are, however, reasons to be optimistic that the debate has moved on since *The Sunday Telegraph* opined in 1971 that any participatory art opportunity '... makes people behave like wild beasts'.[10] This Lozano-Hemmer exhibition, as a substantial body of work showing an in depth development of interaction and participation, in a major gallery space, is one of those reasons to be cheerful. The systems involved demand accuracy, delicacy and complexity, and above all, the huge step of handing some control to an audience, whilst gracefully hosting the serious party that might follow.

1. Beuys, Joseph and Dirk Schwarze (2006) "Report on a day's proceedings at the Bureau for Direct Democracy // 1972." In: Bishop, Claire (ed.) *Participation* (Documents of Contemporary Art). Cambridge/London: MIT Press/Whitechapel. pp. 120-124.

2. The discussion of new media art in terms of behaviours, including a chapter on participatory systems, is explored in: Graham, Beryl and Sarah Cook (2010) *Rethinking Curating: Art After New Media*. Cambridge: MIT Press. Graham, Beryl (2010) "What kind of participative system? Critical vocabularies from new media art." In: Anna Dezeuze (ed.) *The 'Do-it-Yourself' Artwork: Participation from Fluxus to New Media*. Manchester: Manchester University Press. pp. 281-305.

3. Discussed in Graham and Cook, ibid.

4. Ranzenbacher, Heimo (2001) "Metaphors of Participation: Rafael Lozano-Hemmer interviewed by Heimo Ranzenbacher." Ars Electronica Festival 2001. ←http://www.aec.at/festival2001/texte/lozano_e.html→.

5. Foster, Hal (2006) "Chat rooms // 2004." In: Bishop, Claire (ed.) *Participation* (Documents of Contemporary Art). Cambridge/London: MIT Press/Whitechapel. pp. 190-195.

6. Lozano-Hemmer, Rafael (6 Dec 2001) "Too interactive (belated)." New-Media-Curating Discussion List. (Online). Available from URL: ←http://www.jiscmail.ac.uk/lists/new-media-curating.html→.

7. González, Jennifer (2010) "Race, Secrecy and Digital Art Practice." In: Anna Dezeuze (ed.) *The 'Do-it-Yourself' Artwork: Participation from Fluxus to New Media*. Manchester: Manchester University Press. pp. 185-205.

8. Miessen, Markus and Chantal Mouffe (2007) "Articulated power relations." In: Miessen, Markus (ed.) *The Violence of Participation*. New York: Sternberg. pp. 37-48.

9. Discussed in Graham and Cook, ibid.

10. Bird, Jon (1999) "Minding the body: Robert Morris's 1971 Tate Gallery Retrospective." In: Michael Newman & Jon Bird (eds.) *Rewriting Conceptual Art*. London: Reaktion Books. pp. 88-106. This press comment is from 1971, when the Tate closed the hands-on version of Robert Morris' sculptural art after a few days. In May 2009 the Live Art curators at Tate Modern instigated a successful re-installation the exhibition with systems to cope with the 'risks' of participation.

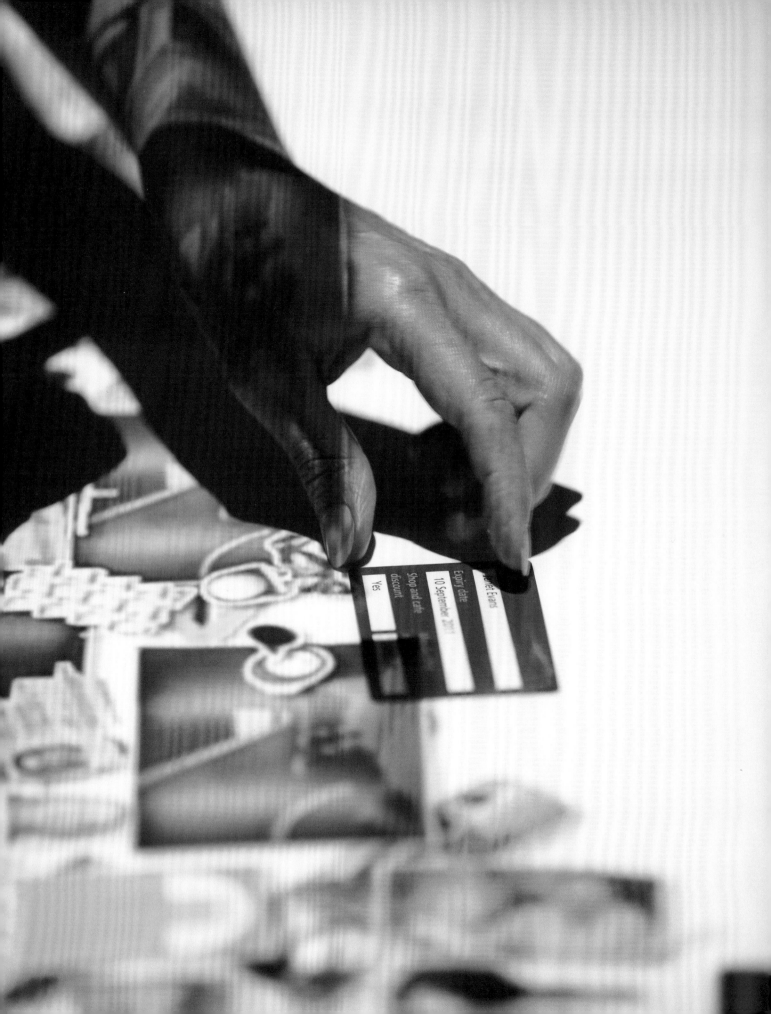

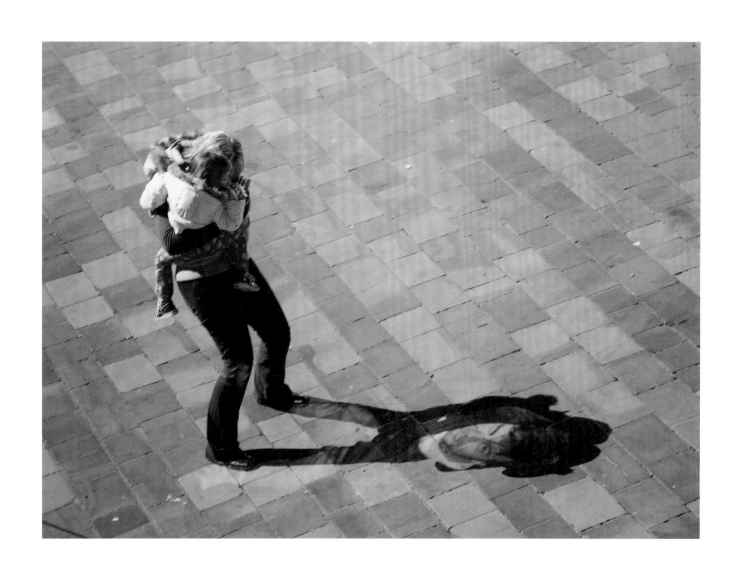

Under Scan 2005.
Public art project featuring
interactive portraits projected
inside the shadows of passers-
by. Commissioned by the East
Midlands Development Agency,
shown here in Humberstone Gate,
Leicester.

Cecilia Fajardo-Hill

Play-Back

(...) No one could distinguish them from living persons (they appear to be circulating in another world with which our own has made a chance encounter). If we grant consciousness, and all that distinguishes us from objects, to the persons who surround us, we shall have no valid reason to deny it to the persons created by my machinery. When all the senses are synchronized, the soul emerges.' [1]

Dr Morel in *The Invention of Morel*, Adolfo Bioy Casares, 1940

The most important source of inspiration for Rafael Lozano-Hemmer's exhibition *Recorders*, is the novel *The Invention of Morel* by Adolfo Bioy Casares, published in Argentina in 1940. A science fiction novel, which anticipates scientific developments, it introduces a post-photographic device which records and projects in three dimensions. What the artist defines as 'co-presence', and 'projected absence', are at the centre of the novel and of Lozano-Hemmer's work. The artist explains: 'A lot of my work is about interpenetration, embodiment and co-presence. I like stressing the way many realities co-exist in the same time and space.' [2]

The Invention of Morel, tells the story of a fugitive who escapes to an uninhabited island with a single building, an abandoned museum. One day he discovers that the museum is not uninhabited any longer, but that a party of people is visiting it, and that the building has recovered its original liveliness. He falls in love with an enigmatic woman called Faustine. After the strange and sudden disappearance of the party, he discovers that the events in the museum are repeated again and again and that Faustine cannot see or interact with him because developments there are the result of the projection in three dimensions of 'presences' by a strange machine invented by Dr Morel, the host of the party. This machine not only records sight and hearing, but tactile sensations, smell and temperature, and in synchronizing all the senses, the soul. Obsessed by his love and desire for Faustine, he discovers how the machine works and finds the way to superimpose on the events already recorded, a new, carefully staged recording of a fictitious relationship with Faustine that would then repeat to eternity. As the machine records it destroys the life of everything it touches, thus immortality comes at the cost of mortality.

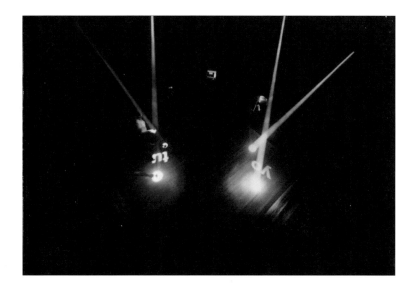

Every work in the exhibition *Recorders* involves a form of memory; the memory of people's faces, heart beats, finger prints, bodies in motion, voices, written words, and objects. This superimposition of bodies over bodies, experiences over experiences, implies that you experience someone else within your shadow. There is a sense of losing and encountering the self in this exercise. Both the authority of the artist and the self in the spectator are destabilized. The artist explains: 'There are notions of otherness, complicity and puppetry that I hope are elicited'[3]

For example in *Body Movies*, 2001, photo portraits of people were taken on the streets of the cities where the work is exhibited. The portraits only appeared inside the projected shadows of the public passing-by. *People on People*, 2010, a work commissioned for this exhibition, is described as 'a large-scale interactive installation designed to displace the public's image in real-time, creating a platform for embodiment and interpenetration'. In this work, as people walk around the space, they view the shadows of live and recorded images of other visitors while being recorded themselves to be played back on someone else's shadow. In *Microphones*, 2008 – on view in *Recorders* – an interactive installation featuring 10 vintage microphones, the public is invited to speak into a microphone, and automatically the voice is recorded while the voice of a previous participant or a recording at random from up to 600,000 that each microphone can store is played back. As the work speaks back to the participant, again a dialogue is being established with an other who most likely will be an unknown entity. In *Close-Up Shadow Box*, 2006, also in the show, a similar phenomena occurs, whereby when a person stands in front of the box, it automatically begins recording a video of the spectator, and inside the viewer's silhouette,

it reveals hundreds of small videos of other people who have looked at the piece previously. The overlay of the shadow, of the voice, of the bodies, of the memory and trace of the other, while creating both uncertainty and intimacy, brings awareness of the self.

Electronic art[4] encounters more opposition and critical disbelief than more conventional forms of art. Because of the generalized ignorance towards technology in the art world and the close association of technology to mass consumer culture we tend to automatically distrust its subjective and poetic potential, even its conceptual and transgressive characteristics. Also, electronic art is inevitably associated with an idea of the new which is often contrary to the more subtle, complex and ambitious workings of the art. The pioneers of today's complex artistic activity involving technology and science go way back, particularly to the experiments of the turn of the 19th century by people such as Étienne-Jules Marey, Eadweard Muybridge, Edison and Lumière. One of the fundamental aspects shared by science and art is its experimental, creative, research-based quality, as well as its interdisciplinary nature. Today's electronic art would not exist if artists such as Picasso (collage) and Duchamp had not incorporated found objects into art; kinetic artists, photographers, and pop artists, or electronic musicians, would not have experimented with industrial materials, without conceptual art's emphasis on ideas; without the live art and interactivity proposed by Dada, Fluxus artists, Happening, Performance artists; and without experimentation with technological innovation by video artists, filmmakers, installation artists, and so forth. Today's electronic art is part of a continuum of exploration and transgression; of a conceptual, aesthetic, subjective

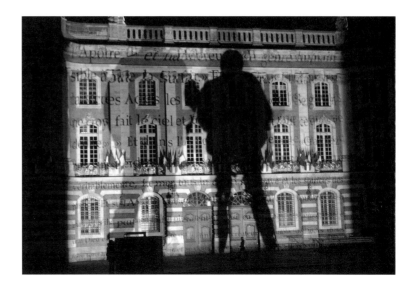

and poetic experimentation. Technology and the individual are inseparables, they occupy the same space, they coexist inevitably.

Duchamp in the early twentieth century created the ready-made, where everyday mass-produced objects were displayed in art galleries, and as David Batchelor has argued, via this displacement on to an un-worked industrial object, 'Duchamp sought to draw attention, not to the intrinsic beauty of bicycle wheels and bottle racks but to the conventions, habits and prejudices underlying our expectations of art and of the circumstances under which we normally view it.'[5] In contrast to the Purists who saw machinery as the embodiment of the highest form of human achievement, or the Futurists' celebration of machinery as the core of modernity, Dada artist Francis Picabia created a series of 'Mechanomorphic' portraits, diagrams made of collaged mechanical forms, and pictures where he copied and pieced together fragments of technical illustrations that resulted in absurd machine-like forms which often possessed anthropomorphic qualities and sexual connotations. These works are simultaneously an acknowledgment of how the modern machine had become part of human existence while literally deconstructing the logic and power of the machine. These were times of war, and the machine was associated negatively to war's destruction, in the same way that today's artists working in technology, such as Lozano-Hemmer, question the way the state uses surveillance technology to oppress and classify people. In 1936 the Surrealists organized an exhibition of Surrealist Objects at the Galerie Charles Ratton in Paris. In this exhibition works ranged from ready-mades by Duchamp, to 'Mathematical Objects' from the Institut

Poincaré in Paris, the latter ones with the idea that the rationalist opposition between scientific and poetic objects was superfluous. The Surrealists embraced the idea of metaphor conceived as a state of ambiguity where the juxtaposition of two more or less distant realities generated a crisis, a collision of terms, an encounter of sorts. This encounter was often driven by desire. The intersubjective social interaction which emerges from participating in the shadow reflections in works such as *Body Movies* and *People on People*, can be seen as an intimate poetic indeterminate encounter with desire. The realization of desire is brought about by superimposing or linking several consciousnesses or multiple realities in the self. There is a carnivalesque quality – as in Bakhtin – in the experience of works such as these. Through humour, laughter, participation, puppetry, involvement, hierarchies are inverted, the authorial authority questioned, and the boundaries of the self and the other destabilized.

A leitmotiv in Lozano-Hemmer's work – aside from dealing with surveillance issues - is its interactive nature, but not in terms of the public acting in the 'mechanistic' mode of pressing buttons, or responding to a menu-based system. This interaction is not automated and it often involves immersive experiences where the whole body by engaging with the work, engages inevitably with others. The focus of the interaction is that the public, the individual – not the collective – engages and discovers her/himself in connection with others. As Stephen Wilson has explained, as the field of interactivity related to computer-based media has matured, artists and theorists have sought to deconstruct interactivity, to move away from a control based interactivity where the viewer adopts the role of 'passive consumer'. He explains:

'Conventional interactivity comes out of the disciplines of computer-human interface design and engineering, whose agendas focus on efficiency and productivity rather than on more artistic goals such as provocation, discovery, nuance, and exploration.'[6] Interesting artists such as Jim Campbell propose systems that instead of stressing control are influenced by the public's feelings and intuitions. Lozano-Hemmer himself wrote in 1996 a text for *Leonardo* titled 'Perverting Technological Correctness'[7] which calls for transgressing the clichés associated with technology – let's not forget that many of today's technological advances were developed for military, security and market purposes, and the authoritarian implications of many technologies need to be transgressed – and proposes an interactivity which is relational, in lieu of coexistence, encounter, exchange and self-discovery, where the work can produce moments of uncertainty, insecurity, eccentricity, improvisation and absurdity.

The interactivity proposed by Lozano-Hemmer involves Mikhail Bakhtin's concept of intersubjectivity which concerns transgressing the boundary between one's own speech and the speech of others. In the mirror of the self in the other in works such as *People on People*, the authorial voice is a double voice, where the author infuses the spectator's discourse with his intention while still retaining the spectator's voice/image/memory. The spectator is not passive, but participates in the shaping of the author's voice/work. Understanding that one's speech is always and already formed out of the speech of others, and always seeks a response from others, Lozano-Hemmer's interactivity is dialogical, not authoritarian, and it involves the interpenetration of the authorial with the other. As this dialogue is open, it is somewhat unpredictable. This dialogical situation has a multiplying effect; as the author somehow loses himself in the other, the spectator loses her/himself in others too in an interminable cycle. In the same way that Dr. Morel recorded his guests at the museum and their tridimensional shadows, creating a virtual though tangible posterity, the viewers in Lozano-Hemmer's exhibition, in becoming participants, will be recorded to be converted then into someone else's experience.

A metaphor for the shadows in Lozano-Hemmer's work, and relating to Morel's projected images, can be found in Italo Calvino's *The Nonexistent Knight*, 1952, which relates the adventures of the knight Agilulf at the time of Charlemagne; he is virtuous, perfect and faithful and his only problem is that he does not exist. At the end of the story he removes his armour and disappears. This story calls for some parallels to be drawn also with the Fugitive's affirmation of immateriality in *The Invention of Morel*, in a certain ambiguous though dialogical relationship with corporeality. The experience of the self – or the other – through someone else's shadow is 'virtual' though it is vivid, poetic and real. Lozano-Hemmer states: 'In modern science, there exists the idea that the vacuum is a place of enormous quantum mechanical activity... at any given moment, matter and anti-matter are created and destroyed... The result over time is zero but this is the sum of all the reactions that occur below the threshold of Heisenberg's uncertainty principle.'[8]

'A single garden, if the scenes to be eternalized are recorded at different moments, will contain innumerable paradises, and each group of inhabitants, unaware of the others, will move about simultaneously, almost in the same places, without colliding.'[9]

1. Adolfo Bioy Casares, *The Invention of Morel*, Prologue Jorge Luis Borges, Translation 1964, Ruth L. C. Simms (New York: The New York Review of Books, 2003. First published: Buenos Aires, Argentina, Editorial Losada, 1940) p. 71.

2. "Rafael Lozano-Hemmer in Interview with Cherie Frederico", *Aesthetica*, Issue 36 Aug/Sept 2010 pp. 30-33.

3. Ibid

4. Much debate and contradiction exists in regards to the terminology used for technology based art and no single term may suffice as encompassing nomenclature. Terms such as information art, digital art, media art, electronic art, are being used, nevertheless terms such as Information and digital art, even though not inappropriate, leave out important formal, material and social aspects of the work such as interaction. Definitions such as participation art, relational art, interactive art may not be specific enough to the medium. Terms such as contemporary or experimental art, though defining, are simply too general. The choice of Electronic art as terminology in this text is done knowingly of its partial adequacy.

5. David Batchelor in *Realism, Rationalism, Surrealism: Art between the Wars*, Briony Fer, David Batchelor and Paul Wood (New Haven & London: Yale University Press, in association with the Open University, London, 1993) p. 35.

6. Stephen Wilson, *Information Arts: Intersections of Art, Science and Technology*, Leonardo Series, (Cambridge, Mass: MIT Press, 2002), pp. 653-654.

7. Rafael Lozano-Hemmer, "Perverting Technological Correctness", *Leonardo* (Cambridge, Mass: MIT Press, 1995).

8. Rafael Lozano-Hemmer, correspondence with the autor,. 7th July 2010.

9. Adolfo Bioy Casares, Ibid, p. 83.

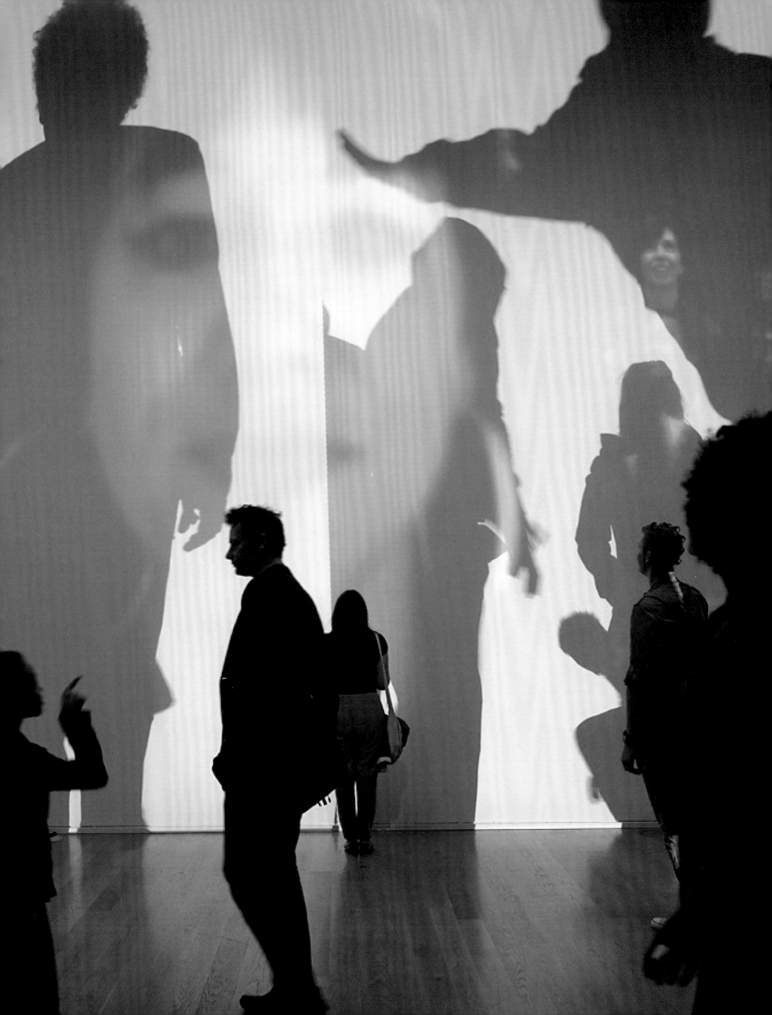

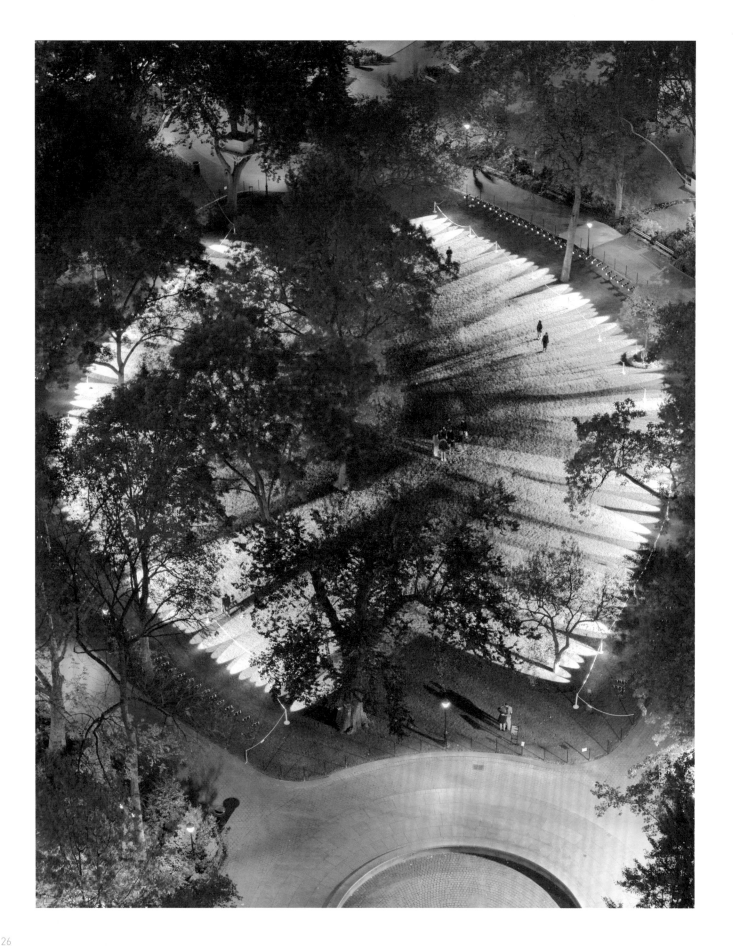

Timothy Druckrey

Bodies, voices, pulses, traces, profanations…

… all communities larger than primordial villages of face-to-face contact are imagined. Communities are to be distinguished, not by their falsity/genuineness, but by the style in which they are imagined. [1]

Benedict Anderson, *Imagined Communities*

I.

The history of the 'media arts' has come over-loaded with metaphors of 'life on the screen,' information revolution, the end of privacy, the loss of intimacy, the triumph of systems, the hype of the 'global village,' the virtualization of memory, the end of literature, etc., etc. How strange these characterizations seem in terms of the breath of works that have emerged in the last decades. From the outset, media art has evolved creative discourses and projects that have largely defined a relationship with communication, identity, intimacy, shattered narrative, and dematerialized social politics – from the alternative spaces of the 60s to the immateriality of cyberspace. This history, written in fits and starts, experiments, and interventions has provided an odd electronic hypothesis in which social fragmentation, nomadic identity, expert discourse, and information systems are linked with critical art practices ranging from critiques of simulation to the assimilation of technology into every aspect of social interaction.

Enveloped in the conditions of unremitting immediacy, mutable or schizoid selfhood, the illusions of social networks, or increasingly regressive 'publics' of the cybersphere, the challenge to the 'media arts' is as much to confront extant and emerging change (or better as Alvin Toffler called it, the 'premature arrival of the future') as it is to abandon inert, rhetorical, solipsistic, and often essentialist observer-based models (whose effectiveness seems less and less relevant) for adaptable systems in which the shifting terrains of social discourse (as it is circumscribed by technology industries), subjectivities (as they are extended by 'personalized' digital communications), embodiments (as they are prostheticized), or 'publics' (as the crumbling

Pulse Park 2008.
Vital signs of the public control 200 theatrical spotlights that illuminate the oval lawn at Madison Square Park, New York City.
Photo: James Ewing.

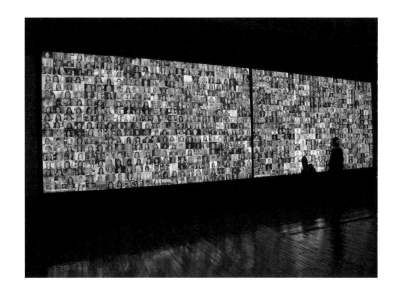

of local spheres are de-spatialized into zones of pseudo-consensus), emerge as signifiers of creative transformations in which 'stability' is disentangled from stasis or immutability and superceded by contingent and situational conditions whose drive is not towards fulfillment or resolution but towards more immediate and/or circumstantial consequences or contingent events.

This conditional sphere has been shadowing the arts for more than a century and as much fueled the historical avant-garde as it did Actionism, Happenings, Situationism, Land Art, Performance, etc., and drives the current frenzy of festivals, biennales, social networks and, particularly, a 'media art' freed of any real dependence on crumbling institutions to frame or legitimate it. It is clear that for some time contingency has prevailed in supplanting the 'stability' of the 'commodity aesthetic' haunting an art scene largely unprepared for a serious art to emerge without its sanction (though occasionally with its reticent or farcical assent).

If we have learned anything from within the media art scene in the last decades, it is that communication media have radically altered the closed-system of critical expertise that so limits institutional thinking. And it has done so without succumbing to the vague populism that so many feared and it has done so by provoking and expanding the conditions in which aesthetic activity can take place and it has done so by mastering technologies in ways that defy facile solutions and by probing not the centrality of artistic identity but rather by probing its limit conditions, not by the mere restaging of an often solipsistic system but by embracing machines (and networks) engineered for sheer functionality and by reimagining and refunctioning them in the service of the imagination.

Interrogating machines, information processing, digital reproducibility, individual autonomy, the 'legitimation crisis' of post-modernity's inebriation with broken narratives, the phony digital triumphs of Hollywood cinema, the now incessant remixing of history, the dismantling of expertise in favor of blogs or tweets and meta-commentary, the eradication of judgment in favour of blathering opinion, the very conditions of the social, the 'media arts' have, time and again, shattered naïve expectations or glib criticism. In its place we find critical activities aimed less and less toward the fulfillment of grandiose phantasies of the deathless electronic life of 'new media', and more and more an examination of the expanded boundaries of perceptibility, the exploded margins of mere representation, the possibilities not of the virtual but of the unimagined, the uncanny, the necessity of the marginal, the resistance to the faux delights of consumption in the face of an avalanche of 'newness' as the special effect par excellence, and a reinvigorated sense of aesthetic activities outside of the hallowed institution and back in the old – but reimagined – public sphere!

II.

I shall call an apparatus literally anything that has in some way the capacity to capture, orient, determine, intercept, model, control or secure the gestures, behaviors, opinions, or discourses, of living beings. Not only therefore prisons, madhouses, the panopticon, schools, confession, factories, disciplines, juridical measures, and so forth ... but also the pen, writing, literature, philosophy, agriculture, cigarettes, navigation, computers, cellular phones, and, why not, language itself, which is perhaps, the most ancient of apparatuses – one in which thousands and thousands of years ago a primate inadvertently let himself be captured,

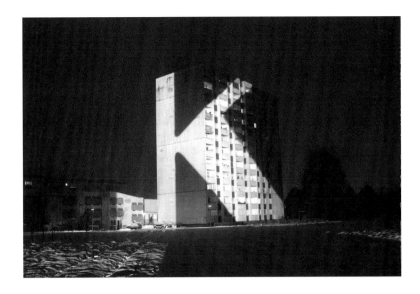

probably without realizing the consequences that he was about to face. [2]

If we follow Agamben's argument in *What is an Apparatus?*, we learn that 'apparatuses must always imply a process of subjectification' and continues, 'that is to say, they must produce their subject.' Yet Agamben also sees the intricate link between subjectification and desubjectification as he laments the influence of gadgets and particularly the cell phone: 'a desubjectifying moment is certainly implicit in every process of subjectification' (p.20) as he identifies 'two great classes 'beings' and 'apparatuses' and 'between these two, as a third class, subjects.' (p14). This triad – being → subject → apparatus – constitutes the tortured metaphysics of the contemporary. Agamben sees the 'subject' as 'that which results from the relation and, so to speak, relentless fight between living beings and apparatuses' and proposes 'hand-to-hand combat with apparatuses' by means of 'profanation' ... 'to profane' (in the Classic sense) he proposes, is 'to restore the thing to the free use of men' and thus 'profanation is the counter-apparatus'(19)[3], the measure of resistance to complicity or assimilation.

A curious cautionary tale whose complexities are increasingly hard to resist as 'smart' technologies envelop, monitor, regulate – but also one that stubbornly clings to both a static reading of the apparatus and that forgets that the entire history of modernity has precisely to do with mediated experiences the consequences of which – as Agamben himself acknowledges by positing language itself as the archetypal apparatus – form the core of an entire history of the role of representation.

Yet Agamben is hardly the first to enjoin on the aversion towards the effects of the apparatus. Heidegger, Mumford, Ellul, Kittler, and many others have lamented the losses wrought by the capitulation to technique and it's apparatuses. Heidegger's 'a representation ... is not being,' Mumford's 'magnificent bribe,' Ellul's 'technological bluff,' Kittler's age of 'nonsense', form a chorus of opposition to the reverberations of the 'triumph of technique'. Indeed Virilio, choral master of this mourning, urges that 'we must at least resolve ourselves to losing the sense of our senses .. ready to lose our morphological illusions about physical dimensions ...which, in the electronic interface, affect the order of sensations' a condition where 'the absence of any immediate perception of concrete reality produces a terrible imbalance between the sensible and the intelligible.' [4]

Losses, bribes, bluffs, nonsense, imbalances ... these stark diagnostic metaphors do come as serious considerations and yet also come as resistant to the forms of transformation, mobility, and agency of media culture and that too often flounder in clearly distinguishing between the apparatus, the medium, the interface and the culture that has rapidly propagated and thrives in an unimagined electronic sphere that has shattered the conventions of modernity's nostalgia for stability and equilibrium.

The 'prognosticators' of these transformations come from broad arenas. Norbert Weiner realized that 'Every instrument in the repertoire of the scientific instrument maker can become a sense organ,' Marshall McLuhan that 'Our Age of Anxiety is, in great part, the result of trying to do today's job with yesterday's tools and yesterday's concepts,' [5] Henk Oosterling that 'Within this mode of being – actual and virtual at the same time – presence and absence are

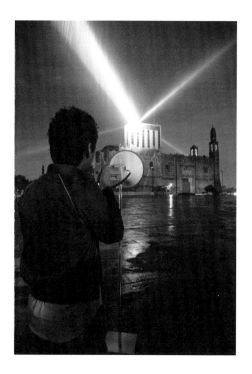

Voz Alta 2008.
A megaphone converts voices into light flashes and a synchronized FM radio signal. Memorial for the 1968 Tlatelolco student massacre, commissioned by UNAM university, Mexico City.

no longer oppositions... Life has become very excessive, even ecstatic. In spite of infrastructural immobilizations like traffic-jams, terrorist threats, tsunamis or physical and digital viruses, our mobility has become part of our selves (auto). The very essence of global consumers is becoming Aristotle's Demiurgos...,'[6] and Peter Weibel said it most cogently: 'Non-identity, context, interactivity, observer, have replaced identity, text, closure, author. That this heroic art of the apparatus world meets with resistance and protest, even though it has founded the logic of the modernity to which it adheres, can only be explained by the ideological ban motivated by man's fears of the void created in modern civilization and modern art by the autonomy of the machine and the disappearance of a familiar reality.'[7]

For our purposes, the most significant shift lies within the implications of 'realities' that are increasingly open-ended, contingent and perhaps unconditional – what might be called anti-chronological, or perhaps suspended, events that disappoint succession, events that are anti-illusionistic, events that emerge in a kind of Deleuzian 'crystallization' but one in which the classical movement/time reciprocity is less relevant than formulations of event flows expressed in elided, compressed, relativised, disintegrated, probablized, indeterminate, subversive, unstable, asynchronous events that are a mix of succession, reversibility and differentiated agency.

Instead we can be confronted by an array of 'temporalities' engaged with the interrogation of systems that defy the normative flows of representability. Here, we are urged not merely to experience banal phenomenal time, but rather to engage in behaviors, assess momentary conditions, interfere with stasis, investigate the instantaneous states of information, probe transitory visibilities, survey the cumulative and relative structures of the archive, measure the effects of presence, consider indeterminate identities, examine the decay of memory, inspect or direct the 'flow' of the event, dissect the repercussions of infinitesimal fluctuations, scrutinize the representation of codes, reflect on seemingly inert systems of surveillance, scan – and perhaps synchronize with – tidal streams of images, experience 'unstable' event-atmospheres. And what emerges in this event-interface, or this in-between, is not the sheer (and paradoxical) stasis of a modernity riveted by speed and resistant to assimilating change, but the unleashing of contingent experiences unburdened by the losses, bluffs, bribes, or imbalances that attempted to sustain the bleak illusion that we've been swindled into inhabiting some phony world that has no substance, no subjectivity, or no meaning.

III.

Theatre is an assembly where the people become aware of their situation and discuss their own interests, Brecht will say after Piscator. Theatre is the ceremony where the community is given the possession of its own energies, Artaud will state. If theatre is put as an equivalent of the true community, the living body of the community opposed to the illusion of the mimesis , it comes as no surprise that the attempt at restoring Theatre in its true essence takes place on the very background of the critique of the spectacle. [8]

Rafael Lozano-Hemmer's oeuvre is a sweeping interrogation of the 'inevitable' assimilation of representation and experience into the unilateral circuits of globalization.

Homographies 2006.
A turbulent array of 144 motorized fluorescent light tubes responds to the movement of the public.
Art Gallery of New South Wales, Sydney Biennale.

Resolutely working in a kind of 'anti-illusion', his work is no longer dependent on primitive modes of recognition or reflexivity. Instead, the works tackle a far more cunning reversal by integrating the 'interference' of the public as the vital dynamic in anti-spectacle, anti-narrative and as an abandonment of the 'regime' of illusions.

The successive works in this exhibition posit the interface as more than just a portal into spectacle; they stand against that kind of phantasmagoria in favour of developing a unique relationship with a distributed public without losing sight of either identity, locality, or with the delicate meanings of interactivity. These works reclaim public space as a site of public discourse, of the social imaginary, of the 'projection' of the public will, and constitute actions at once defiant and compelling.

To 'write' into the edifices of buildings that stand as a repository of cultural history (*People on People*), to 'write' the body into the 'social text' of the physical world (*33 Questions*), to leave the trace of a fingerprint (*Pulse Index*), a heartbeat (*Pulse Room*), a voice (*Microphones*), a face (*Close-up Shadow Box*) propose cumulative meanings that, on the one hand, embed these works in specific – and individual – histories, and, on the other, inhabits them with the bodies, voices, pulses, traces, and profanations of participants willing to suspend passivity and expect more than seeing the mere effect of their individual actions.

In this sense, Lozano-Hemmer is neither attempting to 'build' consensus or to conjure up a useless interaction. Instead the works are an evocation of the kind of social space in which active participation is not a by-product, but the driving force in the creation of a dynamic agora in which every position is established in an open system that ruptures hierarchies and dismantles the notion that the public is an undifferentiated mass, the media merely the harbinger of a utopian global village, interactivity just another opiate for on-line shoppers.

In carefully balancing expansive spaces with individual actions, the works that have been developed by Lozano-Hemmer conspire to reverse-engineer the looming, phantasmatical or cultish extravaganzas whose effects were created to overwhelm the senses, to evoke false unity, or to provide a backdrop for mob rallies. Instead, he relinquishes the crowd in favour of the assembly. The work reminds us that our social spaces are never neutral, that they are inhabited by memories of all sorts, that contingency is not inconsequential, that we are not static, forgotten, stripped-bare by databases, lost in a desubjectified electronic miasma, unable to know what is 'sensible' or 'intelligible.'

Rather than an enclave, Rafael Lozano-Hemmer posits the shared experience as an arena, a social theatre for 'emancipated spectators' in a real 'imagined community.'

1. Benedict Andersen, *Imagined Communities*, (Verso, New York, 1983) p.15.

2. Giorgio Agamben, *What is an Apparatus? And Other Essays* (Stanford University Press, Stanford, 2009) p. 14.

3. Agamben, pp. 20, 14, 19.

4. Paul Virilio, *The Lost Dimension* (Semiotext(e), New York, 1991) pp. 48, 52, 31.

5. Marshall McLuhan and Quentin Fiore, *The Medium is the Massage: An inventory of Effects* (Random House, New York, 1967) p.87.

6. Henk Osterling, Radical Medi(a)crity (published on nettime, 2005). Unpaginated.

7. Peter Weibel, "The Apparatus World – A World into Itself" in *Eigenwelt der Apparate – Welt: Pioneers of Electronic Art* (Ars Electronica, Linz, 1992). p.23.

8. Jacques Ranciere, *The Emancipated Spectator* (ArtForum. FindArticles.com. 01 Aug, 2010. http://findarticles.com/p/articles/mi_m0268/is_7_45/ai_n24354915/) unpaginated.

Works in the Exhibition

→ →→

33 Questions Per Minute consists of a computer program which uses grammatical rules to combine words from a dictionary and generate 55 billion unique, fortuitous questions. The automated questions are presented at a rate of 33 per minute – the threshold of legibility – on 21 tiny LCD screens and on a projection on the façade of the Gallery. The system will take over 3,000 years to ask all possible questions. By means of a keyboard, members of the public can introduce any question or comment into the flow of automatic questions. In Manchester, the questions were also projected onto the façade of the Gallery, producing a rapidly changing inscription for its frieze.

Year of creation: 2000

Technique: Computer, custom-software, 21 LCD screens.

Dimensions: Variable.

Collection: MoMA (NYC), Musac (León), CIFO (Miami) and private.

Pages 36–37

Close-up is the third piece of the *Shadow Box* series of interactive displays with a built-in computerized tracking system. This piece shows the viewer's shadow revealing hundreds of tiny videos of other people who have recently looked at the work. When a viewer approaches the piece, the system automatically starts recording and makes a video of him or her. Simultaneously, inside the viewer's silhouette videos are triggered that show up to 800 recent recordings. This piece presents a schizoid experience where our presence triggers a massive array of surveillance videos.

Year of creation: 2006

Technique: High-resolution interactive display with built-in computerized surveillance system.

Dimensions: Shadow box 104.5 x 80 x 12 cm.

Collection: Private.

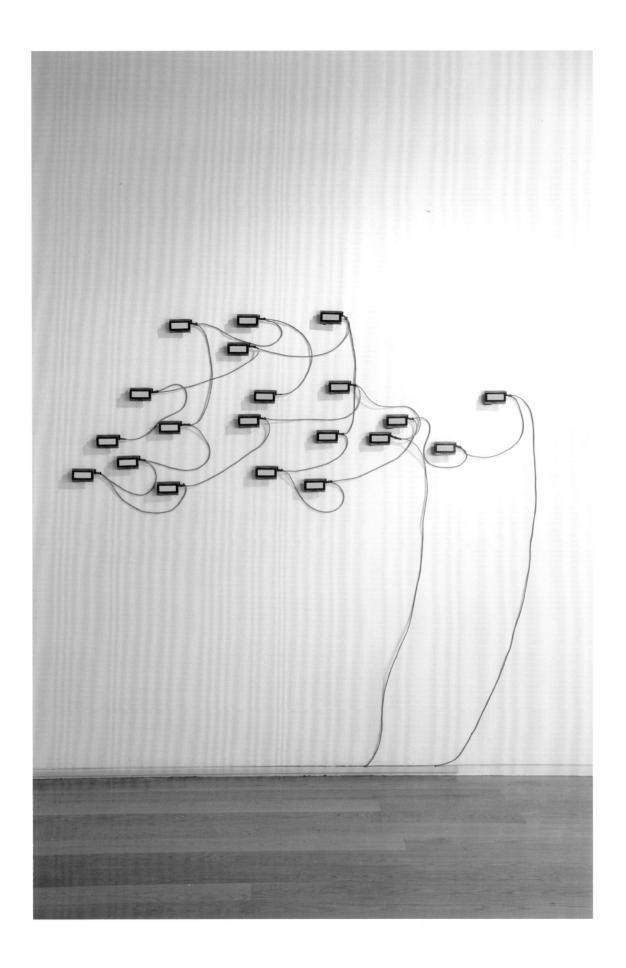

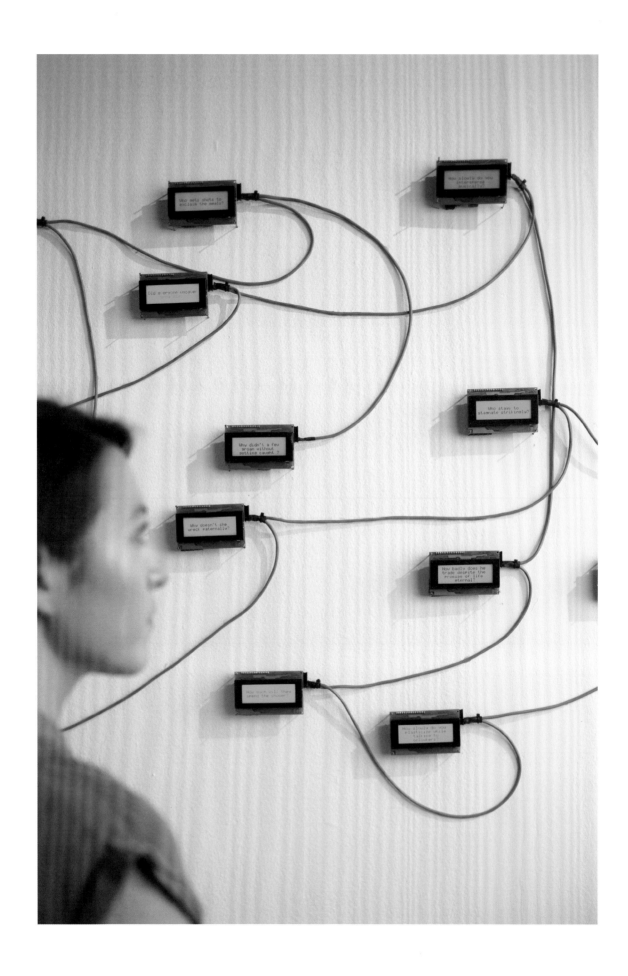

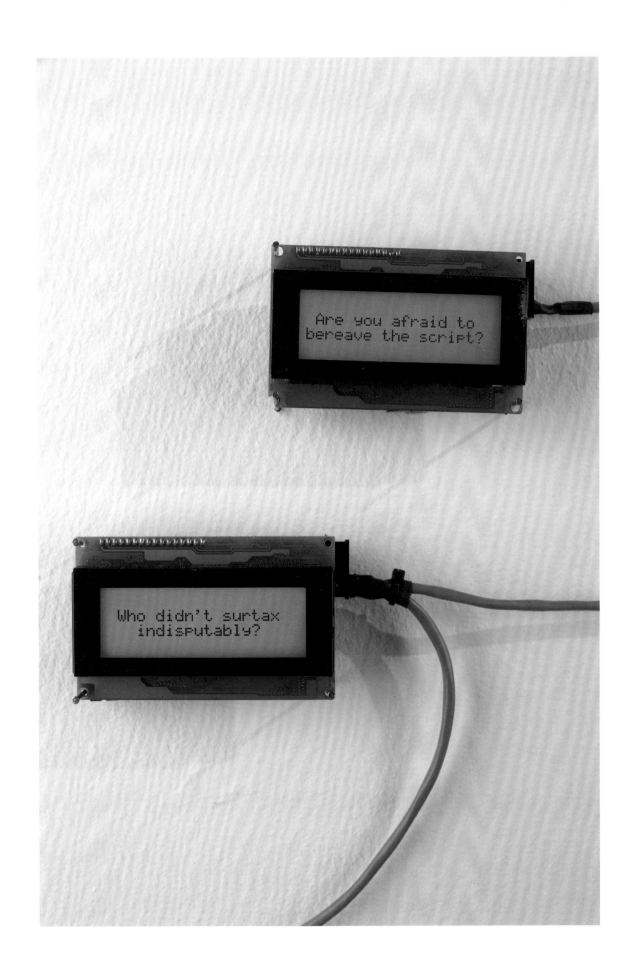

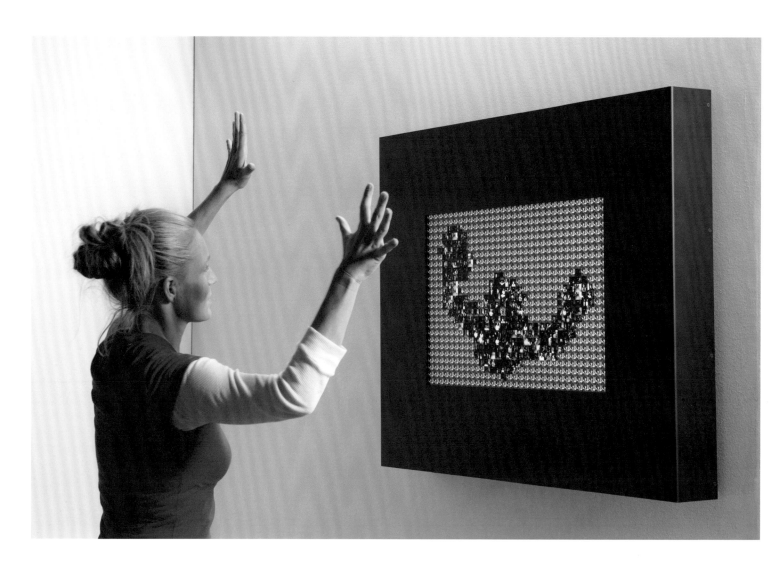

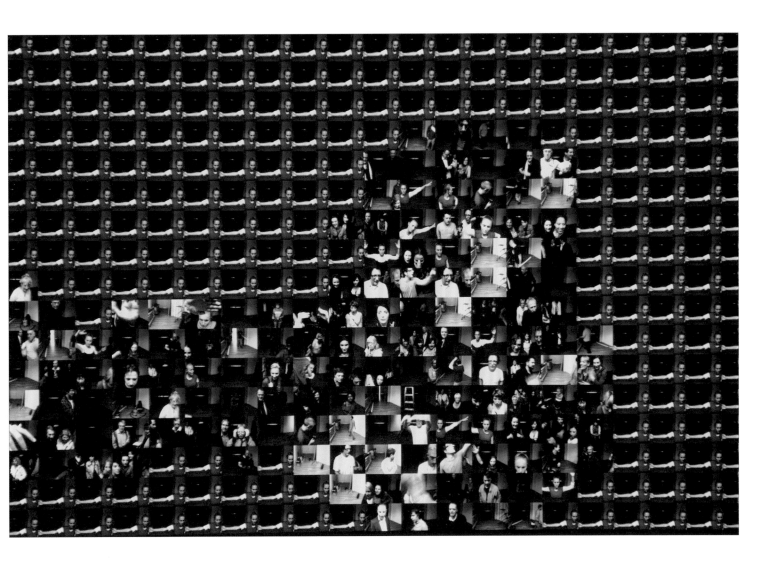

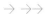

Pulse Room is an interactive installation featuring one hundred clear incandescent light bulbs, 300 W each and hung from a cable at a height of three metres. The bulbs are uniformly distributed over the exhibition room, filling it completely. An interface placed on a side of the room has a sensor that detects the heart rate of participants. When someone holds the interface, a computer detects his or her pulse and immediately sets off the closest bulb to flash at the exact rhythm of his or her heart. The moment the interface is released all the lights turn off briefly and the flashing sequence advances by one position down the queue to the next bulb in the grid. Each time someone touches the interface a heart pattern is recorded and this is sent to the first bulb in the grid, pushing ahead all the existing recordings. At any given time the installation shows the recordings from the most recent participants.

Year of creation: 2006

Technique: Incandescent light bulbs, digital voltage controllers, heart rate sensors, computer and metal sculpture.

Dimensions: Variable.

Collection: Museum of 21c Art (Kanazawa), Karin Srb (Munich), Jonathon Carroll (NYC), Jumex (Mexico) and MONA (Hobart).

Pages 43–45

Microphones is an interactive installation featuring ten vintage microphones, placed on mic stands around the exhibition room at different heights. Each microphone has been modified so that inside its head is a tiny loudspeaker and a circuit board connected to a network of hidden control computers. When a visitor speaks into a microphone, it records his or her voice and immediately plays back the voice of a previous participant, as an echo from the past. The result is surprising because the sound comes directly from the microphone, which 'speaks back', and because it is a memory of what has already been said. Half the time the microphones play back the voice that was just recorded, while the other half they reproduce a recording at random from up to 600,000 that each microphone can store.

Year of creation: 2008

Technique: Modified vintage microphones, electronics, computers and loud speakers.

Dimensions: Variable, each microphone head measures 11 x 8 x 8 cm and each mic-stand base has a diameter of 32 cm.

Collection: Private.

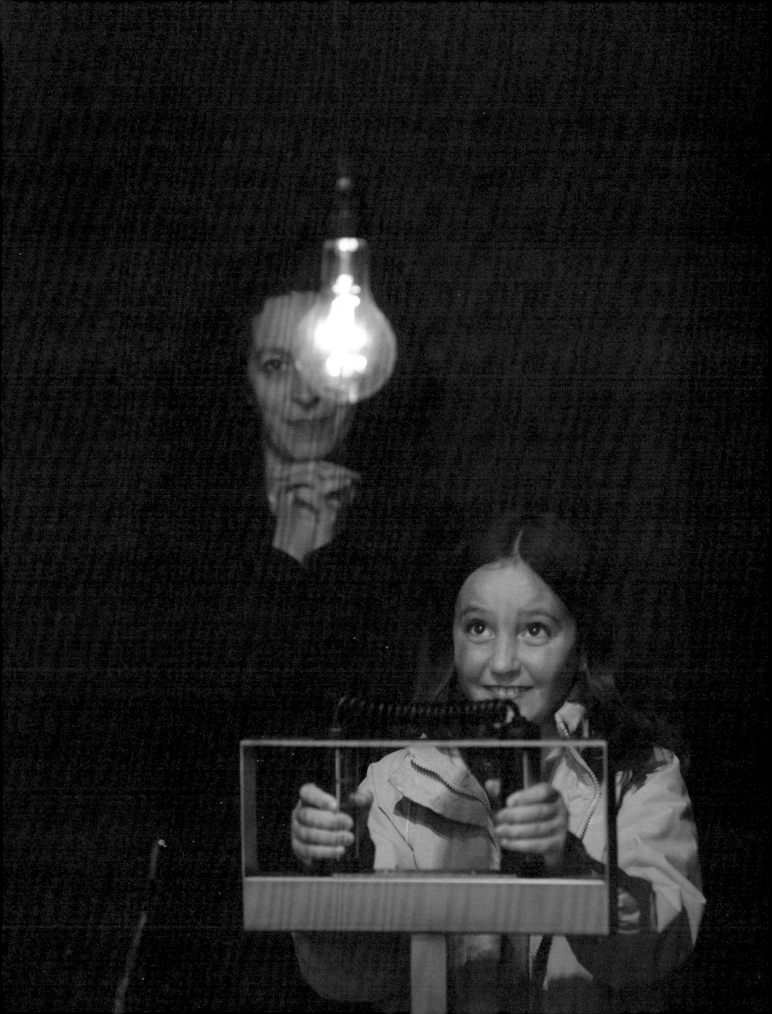

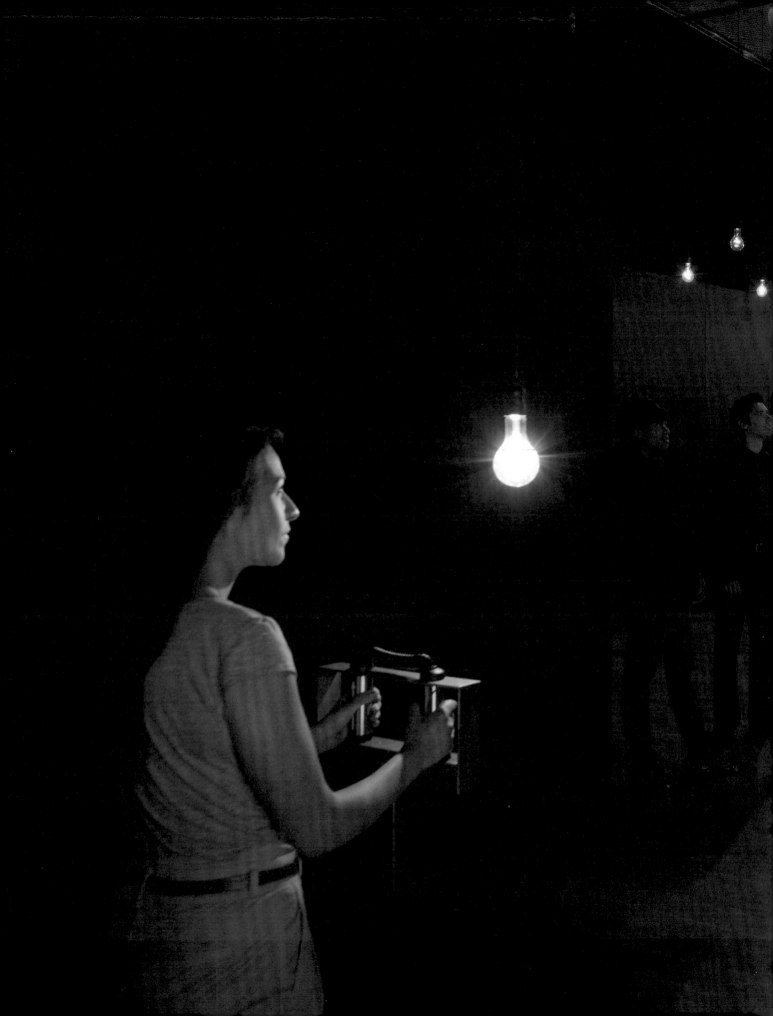

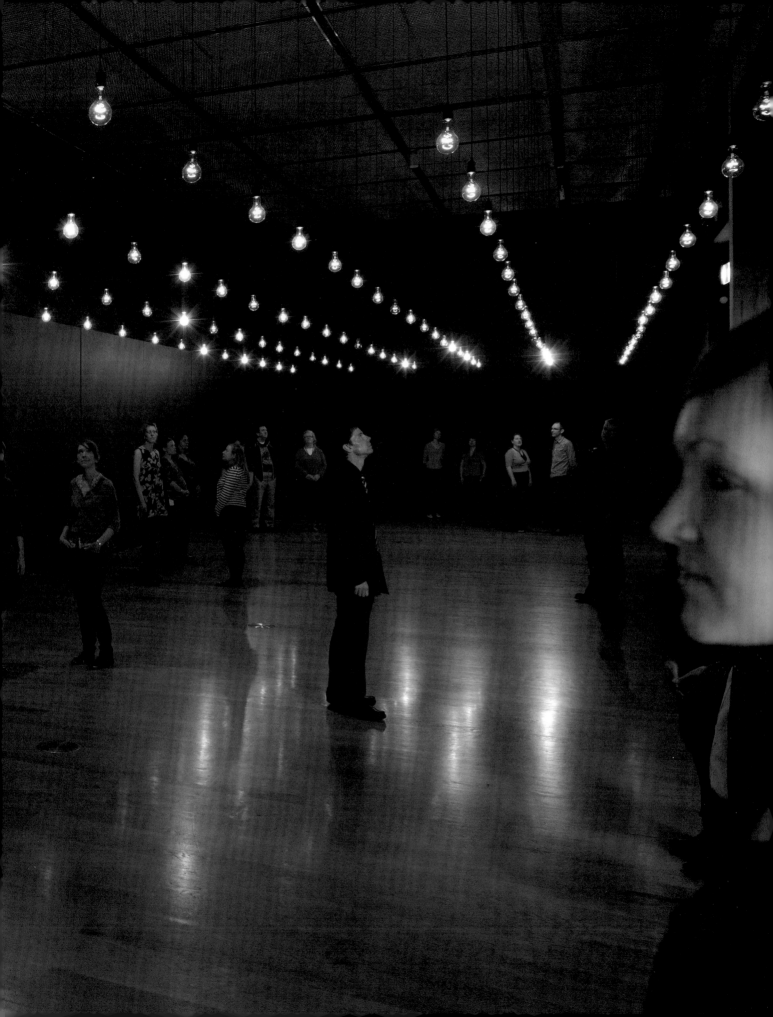

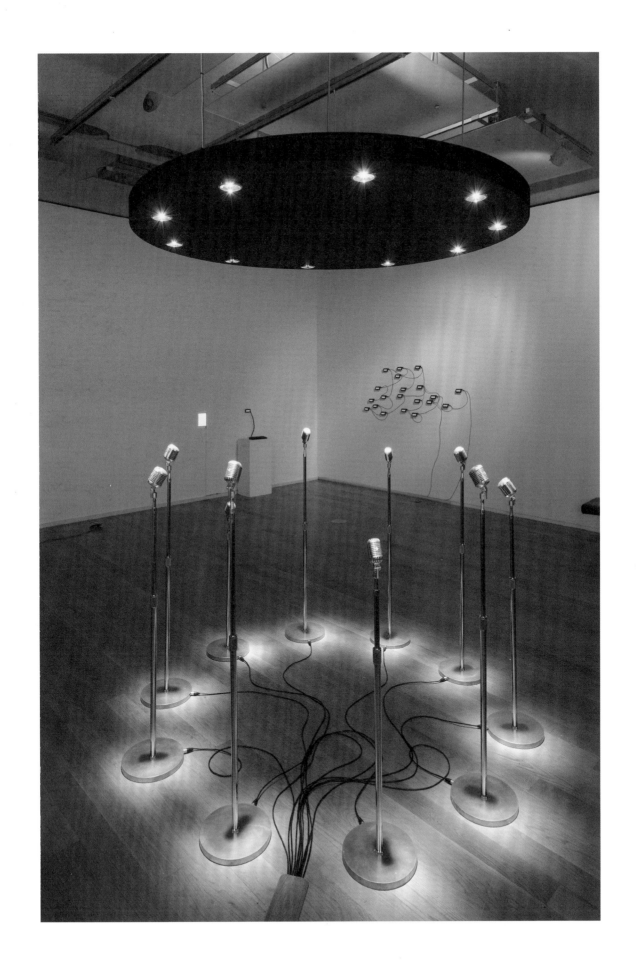

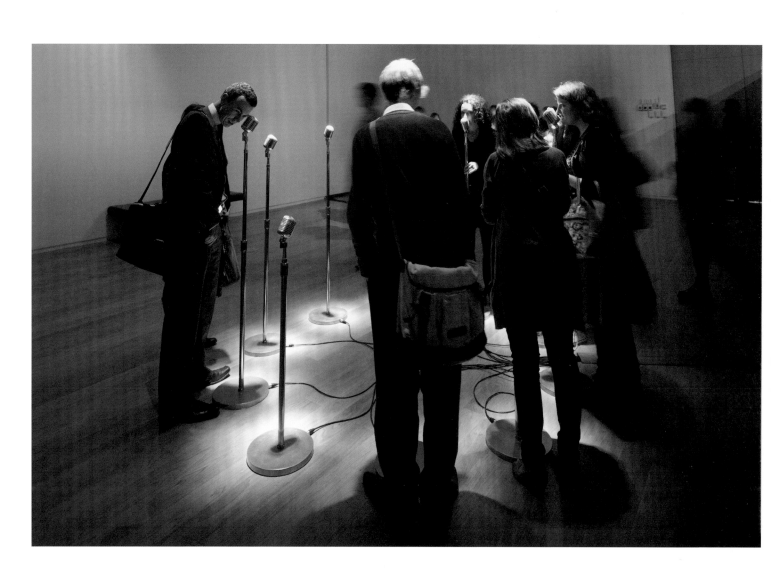

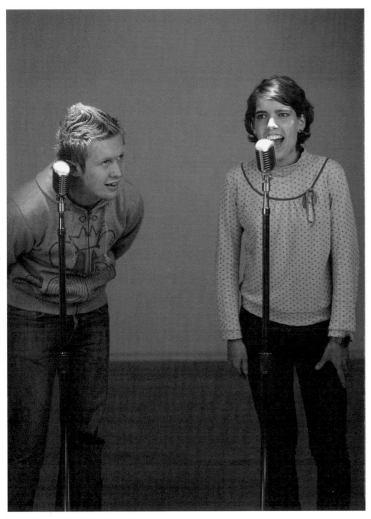
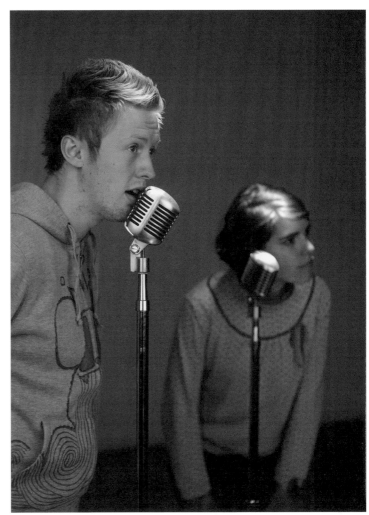

→ →→

Pulse Index is an interactive installation that records participants' fingerprints at the same time as their heart rates. The piece displays data for the last 509 participants in a stepped display that creates a horizon line of skin. As new recordings are added, the oldest ones disappear – a kind of *memento mori*. To participate, people introduce their finger into a custom-made sensor equipped with a 220x digital microscope and a pulsimeter; their fingerprint immediately appears on the largest cell of the display, pulsating to their heart beat. As more people try the piece one's own recording travels upwards until it disappears altogether.

Year of creation: 2010

Technique: Digital microscope, pulsimeter, plasma display, computer.

Dimensions: Variable.

Collection: Daros Latinamerica (Zürich), and private.

Pages 50–52

Please Empty your Pockets is an installation that consists of a conveyor belt with a computerized scanner that records and accumulates everything that passes under it. The public may place any small item on the conveyor belt, for example keys, ID, wallets, worry beads, condoms, notepads, phones, coins, voodoo dolls, credit cards, etc. Once they pass under the scanner, the objects reappear on the other side of the conveyor belt beside projected objects from the memory of the installation. As a real item is removed from the conveyor belt, it leaves behind a projected image of itself, which is then used to accompany future objects. The piece remembers up to 600,000 objects which are displayed beside new ones that are added to the installation.

Year of creation: 2010

Technique: Conveyor belt, mac mini computer, HD projectors, HD camera.

Dimensions: Variable.

Collection: The artist.

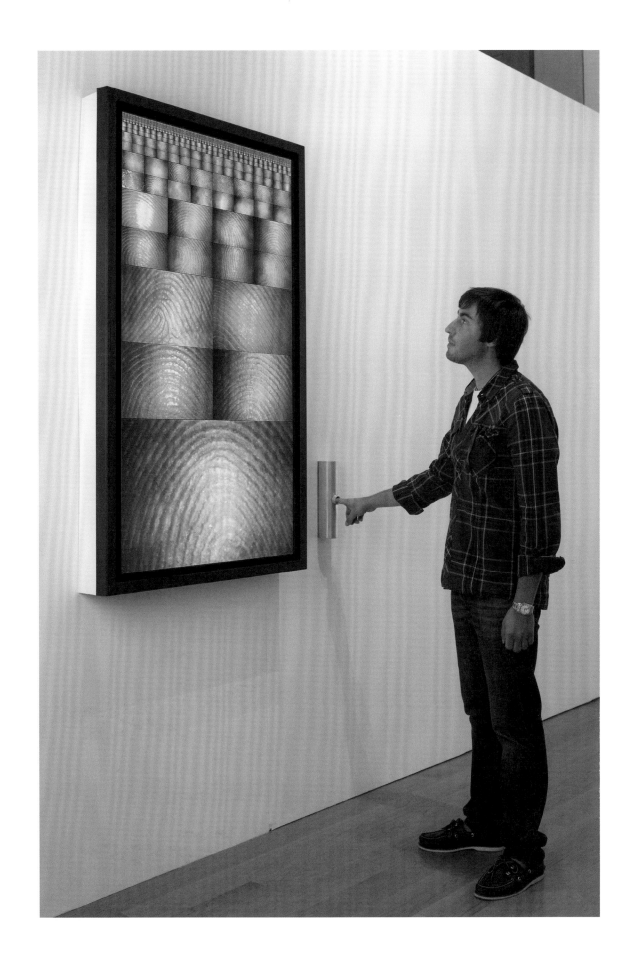

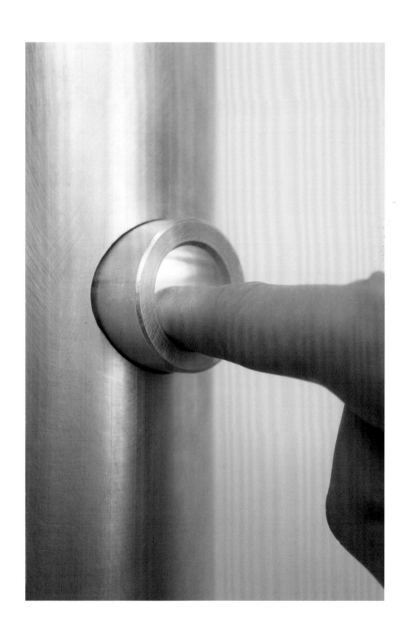

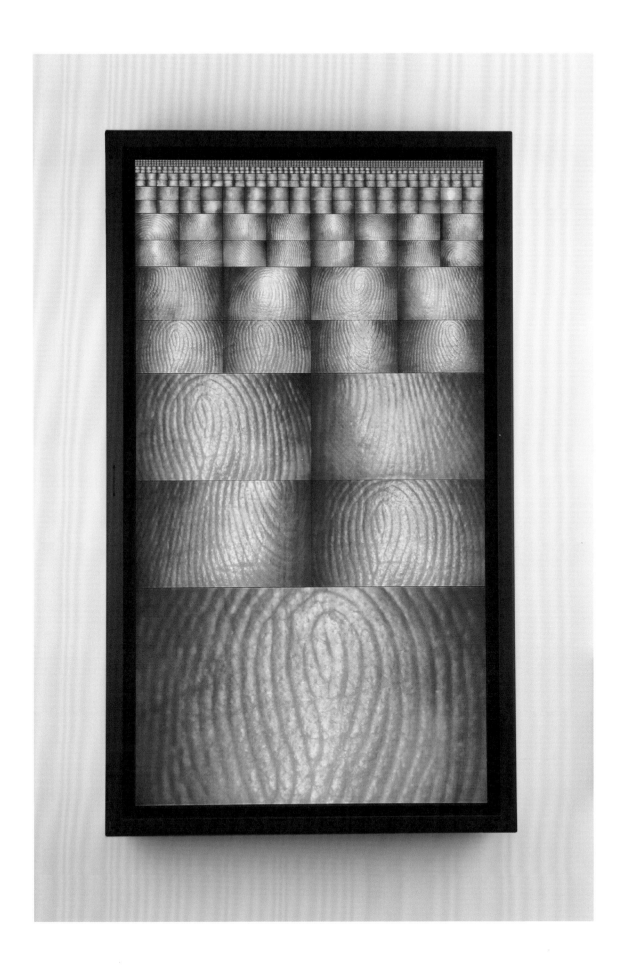

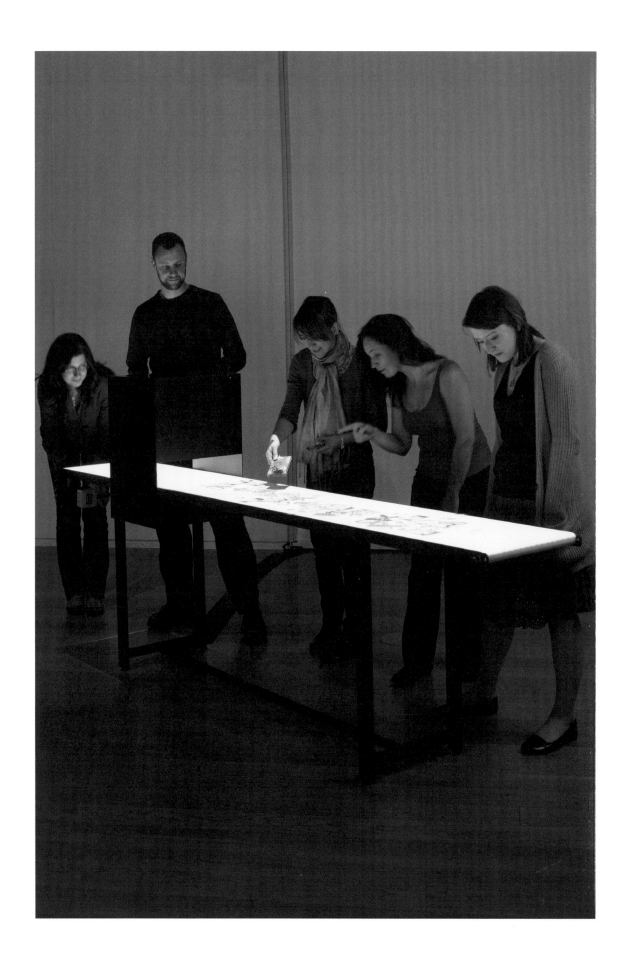

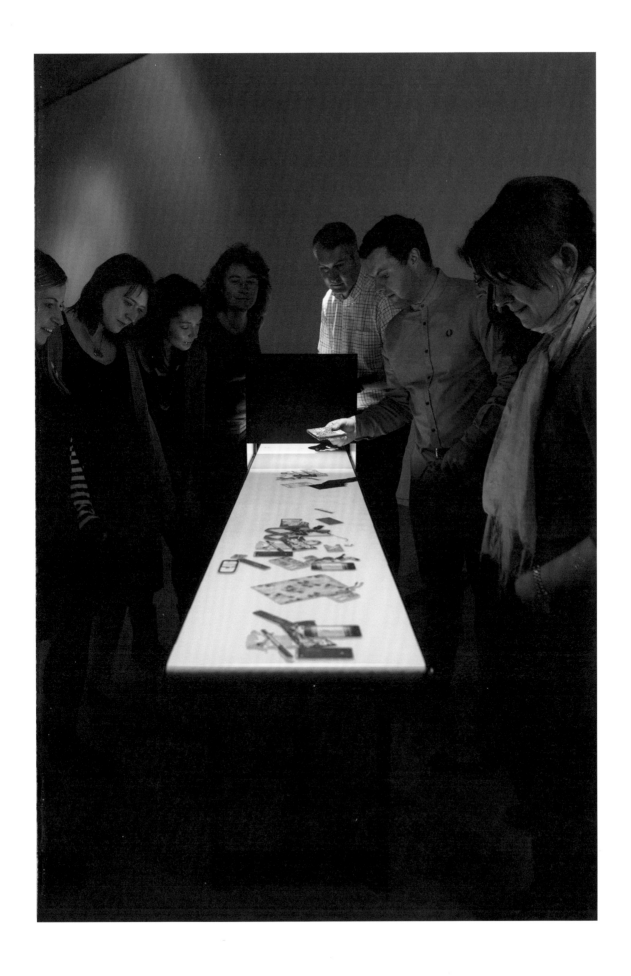

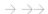

People on People is a large-scale interactive installation designed to displace the public's image in real-time, creating a platform for embodiment and interpenetration. The piece consists of powerful floor-mounted projectors that cast the shadow of the public onto a wall and another set of hanging projectors which project images inside the shadows. As people walk around the room they see inside their shadow the live and recorded image of other visitors, while their own image is recorded for live or delayed playback inside the shadow of someone else. The piece includes high resolution surveillance cameras with face recognition and 3D tracking, turning the exhibition room into one of the world's most advanced scanners. *People on People* is a continuation of Lozano-Hemmer's search for experiences of co-presence, platforms where live transmission affords entanglement and puppetry.

Year of creation: 2010

Technique: Computerized tracking systems, custom-software, projectors.

Dimensions: Variable.

Collection: The artist.

Page 58–59

Autopoiesis When people look at themselves in this small mirror they see the word "Autopoiesis" projected on their forehead. The term 'Autopoiesis' was coined by Chilean biologists Humberto Maturana and Francisco Varela. Literally meaning self-production or creation, it refers to the way in which living beings are seen as systems that produce themselves, or regenerate, in a ceaseless way. An autopoietic system is at the same time the producer and the product. The concept of self-creation is an inspiration for all art that depends on participation to exist.

Year of creation: 2010

Technique: Mirror, surveillance camera, laser projector, proximity sensor, computer running custom face-tracking algorithms.

Dimensions: 51 x 36 x 19 cm.

Collection: The artist.

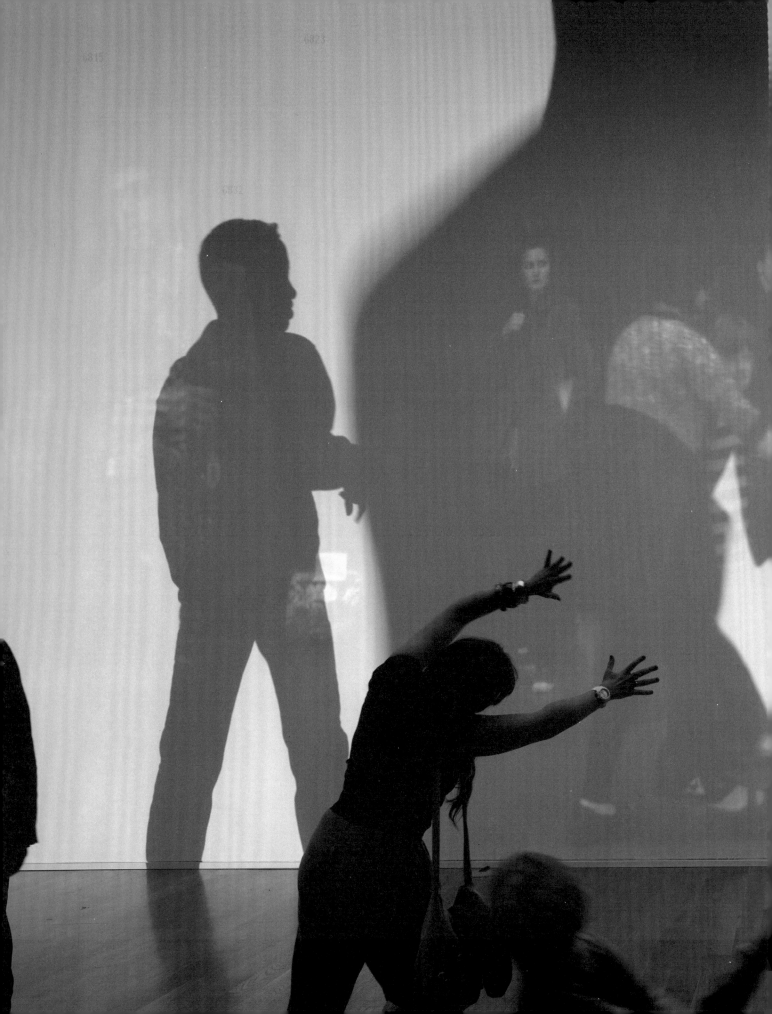

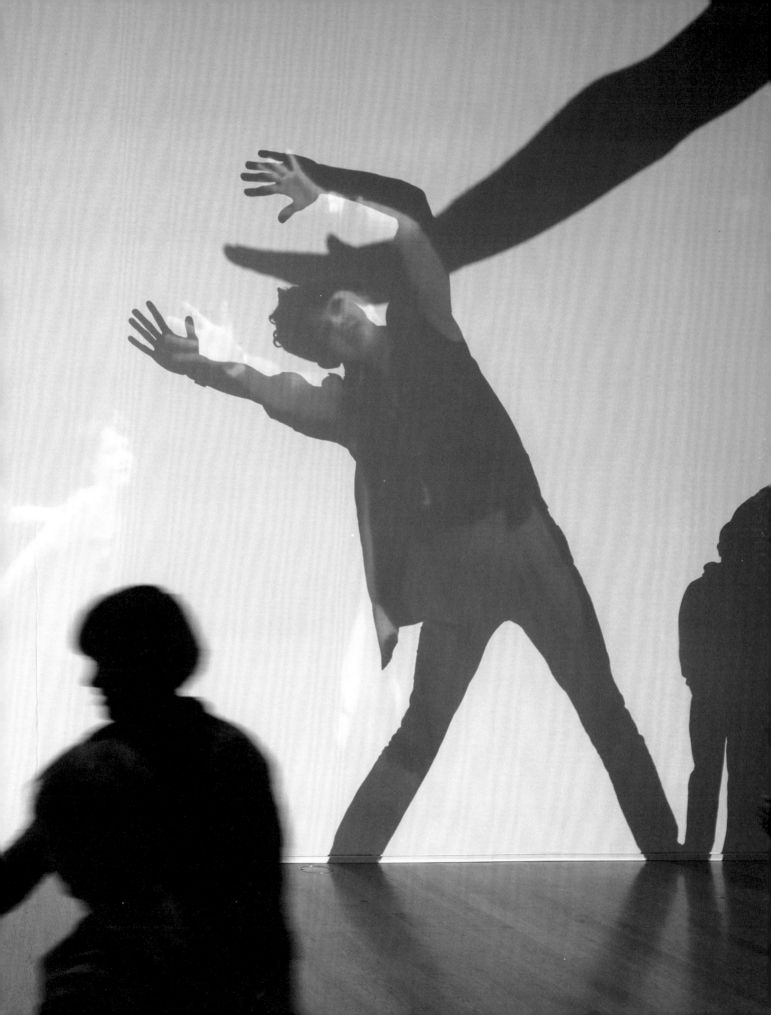

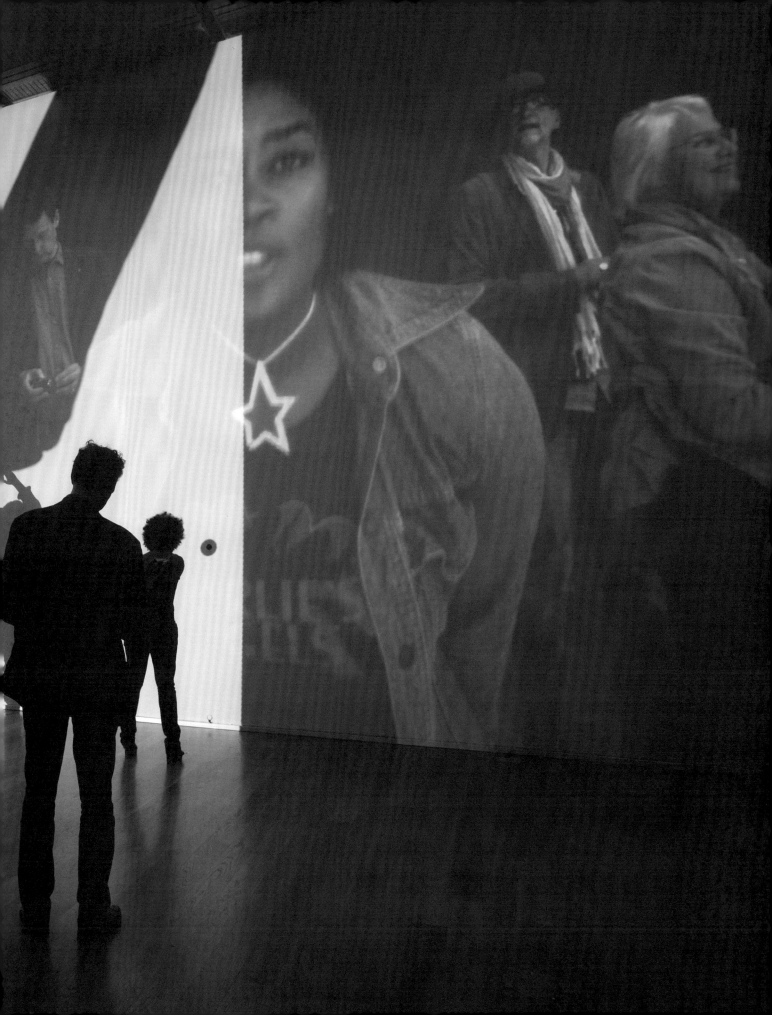

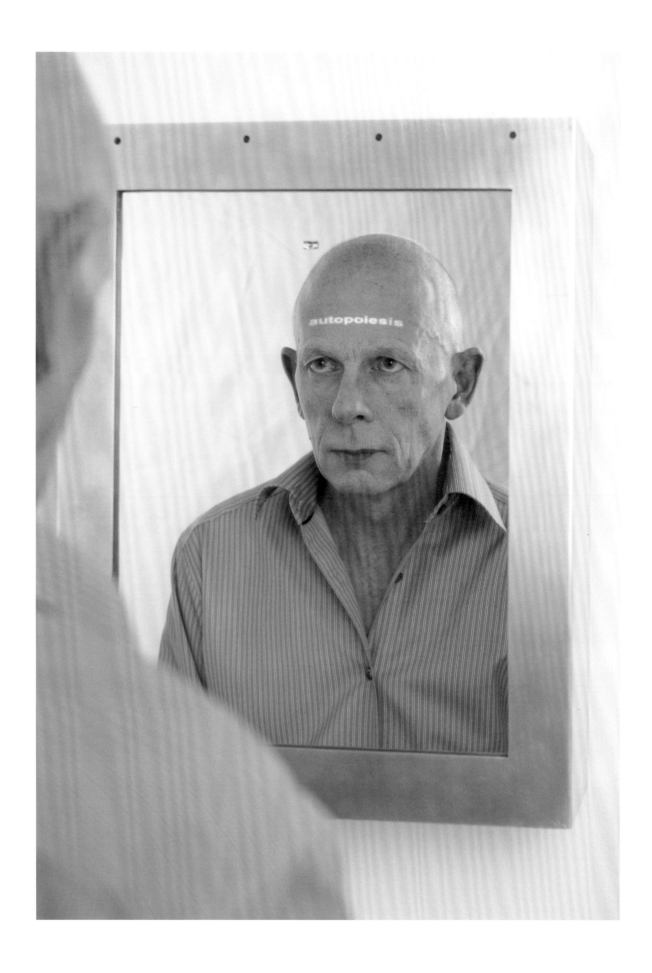

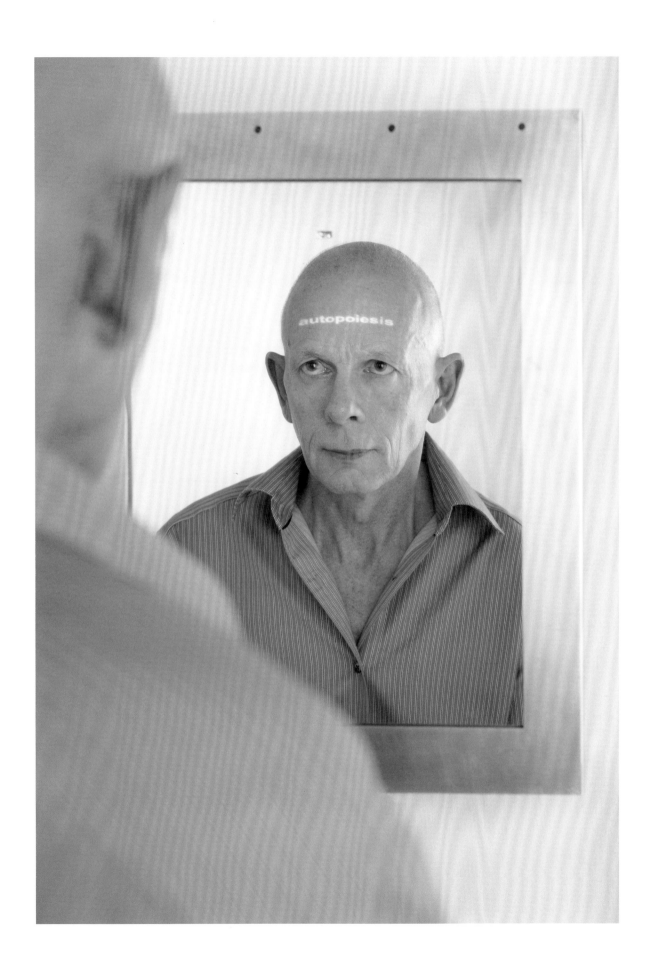

Artist's Biography

Rafael Lozano-Hemmer was born in Mexico City in 1967. In 1989 he received a B.Sc. in Physical Chemistry from Concordia University in Montréal, Canada.

An electronic artist, he develops interactive installations that are at the intersection of architecture and performance art. His main interest is in creating platforms for public participation, by perverting technologies such as robotics, computerized surveillance or telematic networks. Inspired by phantasmagoria, carnival and animatronics, his light and shadow works are 'antimonuments for alien agency'.

Lozano-Hemmer's work has been commissioned for events such as the Millennium Celebrations in Mexico City (1999), the Cultural Capital of Europe in Rotterdam (2001), the UN World Summit of Cities in Lyon (2003), the opening of the YCAM Center in Japan (2003), the Expansion of the European Union in Dublin (2004), the memorial for the Tlatelolco Student Massacre in Mexico City (2008), the 50th Anniversary of the Guggenheim Museum in New York (2009) and the Winter Olympics in Vacouver (2010).

His kinetic sculptures, responsive environments, video installations and photographs have been shown in museums in four dozen countries. In 2007 he was the first artist to officially represent Mexico at the Venice Biennale with a solo exhibition at Palazzo Soranzo Van Axel. He has also shown at Art Biennials in Sydney, Liverpool, Shanghai, Istanbul, Seville, Seoul, Havana and New Orleans. His work is in private and public collections such as the Museum of Modern Art in New York, the Jumex collection in Mexico, the Museum of 21st Century Art in Kanazawa, the Daros Foundation in Zürich and TATE in London.

He has received two BAFTA British Academy Awards for Interactive Art in London, a Golden Nica at the Prix Ars Electronica in Austria, a distinction at the SFMOMA Webby Awards in San Francisco, 'Artist of the year' Rave Award in *Wired* magazine, a Rockefeller fellowship, the Trophée des Lumières in Lyon and an International Bauhaus Award in Dessau.

He has given many workshops and conferences, among them at Goldsmiths college, the Bartlett school, Princeton, Harvard, UC Berkeley, Cooper Union, MIT MediaLab, Guggenheim Museum, LA MOCA, Netherlands Architecture Institute and the Art Institute of Chicago. His writing has been published in *Kunstforum* (Germany), *Leonardo* (USA), *Performance Research* (UK), Telepolis (Germany), *Movimiento Actual* (Mexico), *Archis* (Netherlands), *Aztlán* (USA) and other art and media publications.

Contributors' Biographies

Timothy Druckrey is Director of the Graduate Photographic and Electronic Media program at the Maryland Institute, College of Art. He lectures internationally about the social impact of photography, electronic media, the transformation of representation, and communication in interactive and networked environments. He edited *Electronic Culture: Technology and Visual Representation* and is Series Editor for *Electronic Culture: History, Theory, Practice* published by MIT Press. His other books include *Ars Electronica: Facing the Future, net_condition: art and global media* (with Peter Weibel), Geert Lovink's, *Dark Fiber*; and *Future Cinema: The Cinematic Imaginary After Film* (edited by Jeffrey Shaw and Peter Weibel), Stelarc: The Monograph (edited by Marquard Smith), *Deep Time of the Media: Toward an Archaeology of Hearing and Seeing* by Technical Means (Siegfried Zielinski). Recent exhibitions he has curated include *Bits and Pieces, Critical Conditions* and co-curated *New Media Beijing* (2006). He has been Guest Professor at the University of Applied Art, Vienna (2004) and Richard Koopman Distinguished Chair for the Visual Arts at the University of Hartford (2005).

Cecilia Fajardo-Hill is a Venezuelan/British art historian and curator in contemporary art, currently based in Long Beach, California. She has a PhD in Art History from the University of Essex, England, and an MA in 20th Century Art History from the Courtauld Institute of Art, London, England. Fajardo-Hill is currently the Chief Curator and Vice-President of Curatorial Affairs at the Museum of Latin American Art (MOLAA) in Long Beach, California. Between 2005 and 2008, she was the Director and Chief curator of the Cisneros Fontanals Arts Foundation (CIFO), a non-profit organization devoted to the promotion of contemporary art from Latin America, and the Ella Fontanals Cisneros Collection, an international collection of contemporary art in Miami, USA. She was general director of Sala Mendoza, an alternative space for contemporary art in Caracas, Venezuela, between 1997 and 2001. She has curated and organised numerous exhibitions of emerging and mid-career contemporary artists from Latin America such as Alexander Apostol, Magdalena Fernandez and Javier Tellez, as well as solo shows of international artists such as Susan Hiller, Mona Hatoum and Steve McQueen. At present she is organizing a large survey of Latin American women artists between the 1940s and 1980 together with Andrea Giunta for MOLAA and as a travelling exhibition.

Beryl Graham is Professor of New Media Art at the School of Arts, Design and Media, University of Sunderland, and co-editor of CRUMB. She is a writer, curator and educator with many years of professional experience as a media arts organiser, and was head of the photography department at Projects UK, Newcastle, for six years. She curated the international exhibition *Serious Games* for the Laing and Barbican art galleries, and has also worked with The Exploratorium, San Francisco, and San Francisco Camerawork. Her book *Digital Media Art* was published by Heinemann in 2003, and she co-authored with Sarah Cook the book *Rethinking Curating: Art After New Media* for MIT Press in 2010. She has also contributed to *New Media in the White Cube and Beyond* (University of California Press) and *Theorizing Digital Cultural Heritage* (MIT Press). Dr. Graham has presented papers at conferences including Navigating Intelligence (Banff), Museums and the Web (Vancouver), and Decoding the Digital (Victoria and Albert Museum). Her Ph.D. concerned audience relationships with interactive art in gallery settings, and she has written widely on the subject for books and periodicals including *Leonardo, Convergence*, and *Art Monthly.*

Rafael Lozano-Hemmer

Recorders

**Exhibition Project Team
Antimodular Research**

Programming and hardware
Conroy Badger, Gideon May,
Stephan Schulz

Production
Karine Charbonneau, David
Lemieux, Guillaume Tremblay,
Pierre Fournier, Susie Ramsay,
Boris Dempsey, Yannick Sebag
and Jesse Badger

Acknowledgements
Emily Bates, Jonathon Carroll,
Jennifer Dorner, Tony Harrison
and The Oddfellows, Sabine
Himmelsbach, Nina Miall,
Karin Srb, Alan Ward,
Haunch of Venison Gallery
(London), bitforms gallery (NYC),
Galería OMR (Mexico), Galerie
Guy Bärtschi (Geneva) and Galería
Max Estrella (Madrid).

**Exhibition Project Team
Manchester Art Gallery**

Principal Manager, Exhibitions
Tim Wilcox

**Exhibition Curator and Project
Manager**
Fiona Corridan

Exhibition Curators
Clare Gannaway, Kate Jesson

Exhibition Volunteer
Jennifer Boyd

Registrars
Jennifer McKellar, Phillippa Wood

**Audience Development,
Communications and Design**
Kim Gowland, Jenny Davies,
Martin Grimes, Pauline Minsky

Marketing, Design and PR
Wonder Associates, Brunswick
Arts Consulting LLP

Education
Kate Day, Alex Thorp

Fundraising
Catherine Corlett, Chris Whitfield

**Technical and electrical
installation**
Ged Henry, Adam Butler, Shamus
Dawes

Display Technicians
Allan Rawcliffe , Russell Clarke,
Terry Yiatrou, Peter Hawkins
Elliot Fox

Audio Visual
Mark Haig, Alan Seabright

Security and invigilation
Catriona Morgan and the Visitor
Services team

Retail
Marcus Chase

Published in conjunction with the exhibition

**Rafael Lozano-Hemmer
Recorders**

**Manchester Art Gallery
18 September 2010 – 30 January 2011**
Copyright © for the texts
Manchester Art Gallery and the authors

Copyright © for the design
Manchester Art Gallery and Rafael Lozano-Hemmer

Catalogue design
Pauline Minsky
Printed by Andrew Kilburn Printing Services
Typset using Din and Helvetica
Printed on Hanno art silk

Installation photography
Peter Mallet assisted by Petra Kubisova
With thanks to everyone who took part in the photography.

Manchester Art Gallery
Mosley Street, Manchester. M2 3JL. UK
www.manchestergalleries.org

Antimodular Research
4060 Blvd. St-Laurent, studio 107
Montréal Québec H2W 1Y9 Canada
www.antimodular.com

ISBN: 978-0-901673-78-7 softback
ISBN: 978-0-901673-79-4 signed limited edition hardback